POSTCARD HISTORY SERIES

Old Los Angeles
and Pasadena
IN VINTAGE POSTCARDS

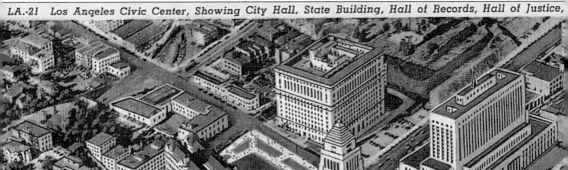

And Federal Post Office and Courthouse Building

© SPENCE AIR PHOTOS

THE CIVIC CENTER. In the area of First Street, Spring Street, and Broadway, the Los Angeles Civic Center is just south of the historic monument and Plaza marking the original site of the city. Los Angeles began in 1781 with 44 Indians, African Americans, and Spaniards as a farming community growing food for California's Spanish missions. The picture here dates from about 1950. The City Hall (with tower) is at center. In counterclockwise order we see the post office and courthouse (upper right), Hall of Justice, Hall of Records, State Building, and Times Building. The old County Courthouse once stood on the vacant lot between the Hall of Records and the Hall of Justice. (Published by Western Publishing & Novelty Co., Los Angeles.)

POSTCARD HISTORY SERIES

Old Los Angeles and *Pasadena*

IN VINTAGE POSTCARDS

C. Milton Hinshilwood and Elena Irish Zimmerman

ARCADIA

Copyright © 2001 by C. Milton Hinshilwood and Elena Irish Zimmerman
ISBN 0-7385-0809-8

First Printed 2001.
Reprinted 2002, 2004.

Published by Arcadia Publishing
Charleston SC, Chicago IL, Portsmouth NH, San Francisco CA

Printed in Great Britain.

Library of Congress Catalog Card Number: 00-110307

For all general information contact Arcadia Publishing at:
Telephone 843-853-2070
Fax 843-853-0044
E-Mail sales@arcadiapublishing.com

For customer service and orders:
Toll-Free 1-888-313-2665

Visit us on the internet at http://www.arcadiapublishing.com

CONTENTS

ACKNOWLEDGMENTS

We would like to thank the following people for their help in obtaining information for this book. Some of this information is quite difficult to find; we are grateful to these friends from California and elsewhere who took the trouble to find answers to our questions. Some of them sent us copies of published material as well. Thank you all.

Adria de Baca of Pasadena Tournament of Roses Association; Lee Brown of Sunland, CA; Mrs. Bonnie Collins of Pasadena; Graham F. Cox of Knoxville; Starla Jacobs of Pasadena Chamber of Commerce; Los Angeles Convention Center and Visitors Bureau; Don Mclaughlin of Pasadena Public Library; Mrs. Patricia Mann of Altadena, CA; Jean Penn of Pasadena Public Library; Tania Rizzo, archivist at Pasadena Historical Museum; Richard C. Schnell of Los Angeles; Debi Simpson of Pasadena; and Rachel Tucker of Los Angeles Board of Education.

C. Milton Hinshilwood
Elena Irish Zimmerman
October 2000

INTRODUCTION

This book is based on a collection of vintage postcards of Los Angeles and Pasadena published between 1900 and 1950, collected and owned by C. Milton Hinshilwood. Having lived for over 35 years in Los Angeles and Pasadena, he has long been aware of the history and geography of these two cities in many personal ways, and shares them here by this means of unique presentation.

There are thousands of pictures devoted to the history of this area; they can be found in books, archives, and private collections. We should not, however, discount the importance of the postcard in conveying the accuracy of an historical event, location, or person. The communication of a postcard is not only thrifty and immediate, but the picture conveys instant history. It says, "Here's where I am now; isn't this an interesting picture?" People have been sending postcards since the 1890s, and the views have always shown "how it was" at the time the card was sent.

The postcard became enormously popular during 1900–1910. Millions upon millions were mailed, and commercial photographers began making pictures of many topics other than geographical views to entice the public. Collectors can find picture postcards of any topic imaginable: the cities of the world, famous people such as Shakespeare or Einstein, airplanes, fashions, Christmas (and all other) greetings, dogs, schools, artists, and royalty—the variety is seemingly endless. They embrace historical as well as contemporary subjects. Los Angeles and Pasadena at the beginning of the 20th century is a very specialized collection, but there are hundreds of postcard pictures of that time and place to be found. The cards collected here document not only the emergence and progression of the scenes represented, but also the prevailing attitudes toward the time in which they were sent. A message, however short, adds valuable human interest, and a postmark always validates the accuracy of the time.

The images presented in this book are categorized into groups: streets, buildings, residences, parks, schools, churches, and a few others, for easy reference. Beyond the general span of 1900–1950, however, no precise chronology has been attempted. Although postcards of a city collected with an eye to history become an important panorama of that city's development, they also picture diverse places and people and offer implicit comment on the social, ethical, and aesthetic values of the decades seen. They illustrate business conditions and people's attitudes toward religion, amusements, art, fashion, and humor.

Los Angeles is BIG—it covers an area of 454 square miles, the largest land area of any city in the world. Its population rivals that of New York City. It has the highest ratio of cars to people in the United States, more furniture than Grand Rapids, and more oil well machinery than any other city except Houston. There are many more "more than" comparisons to make, but they reach beyond our scope here. Los Angeles has the movie business, aircraft manufacturing, a magnificent harbor, and a number of adjacent and individually notable cities such as Beverly Hills, Burbank, Santa Monica, Glendale, and Pasadena. This book will touch upon none of these except Pasadena, which lies just northeast of the downtown area pictured on these Los Angeles postcards.

Los Angeles was founded in 1781 by the Spanish governor of California, Felipe de Neve. Only 44 people lived in the original village. Through the years Los Angeles grew, through its Mexican domination, American annexation (1847), the Gold Rush, the arrival of the railroads (1876), the discovery of oil (1892), and the influx of 500,000 new inhabitants between 1900–1920. Many thousands have come since then, enamored of the tropical elements and opportunities for a good life.

The old part of Los Angeles is at the heart of it, at the historic monument and the Plaza, bounded by Spring and Alameda Streets. Here is the nucleus from which today's big city has spread in all directions. This area is the focus of this book.

Old Pasadena is reflected here with postcards showing evidences of the wealth that came to this city in the 1880s and the annual Tournament of Roses festivities that have made the city famous since the 1890s. After the real estate boom of 1886, the coming of the railroads ensured an influx of wealthy residents who built mansions for themselves or spent winters in hotels like the Green or the Huntington, to enjoy the clear air, the citrus groves, and the glorious mountain views. Pasadena now has a legacy of opulent homes, lush gardens, and outstanding scientific and cultural resources in its libraries and museums.

The authors hope that the reader will enjoy these glimpses of old Los Angeles and Pasadena as much as we have enjoyed assembling them.

LOS ANGELES

One

DOWNTOWN STREETS
AND BUILDINGS

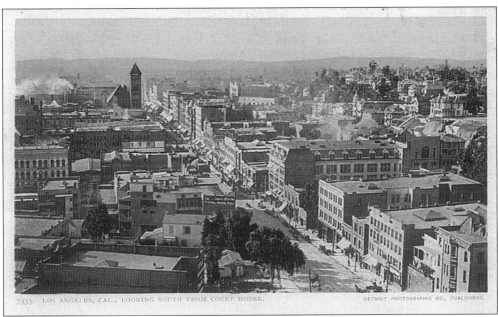

7333. LOS ANGELES, CAL., LOOKING SOUTH FROM COURT HOUSE. DETROIT PHOTOGRAPHIC CO., PUBLISHERS.

LOS ANGELES LOOKING SOUTH FROM COURT HOUSE. A fine, inclusive view here of Los Angeles looking down Broadway shows several important aspects of the city about 1905. The courthouse (not seen) was located at Broadway and Temple. The tower at left center belonged to the City Hall, rising noticeably above the flat-topped buildings which were required at the time. The area at upper right was Bunker Hill, a community of choice residences, mostly Gothic mansions with full corner bay windows and spindle turrets. In time the mansions became shabby and were turned into apartment houses. Finally they were razed to make way for new developments. (Published by Detroit Photographic Co.)

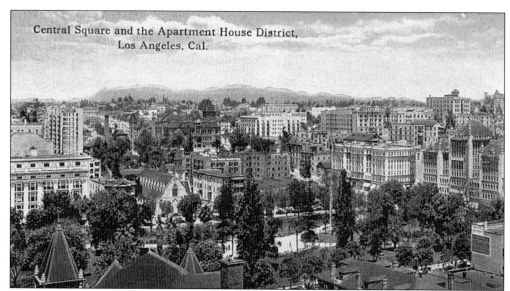

Central Square and the Apartment House District,
Los Angeles, Cal.

CENTRAL SQUARE AND THE APARTMENT HOUSE DISTRICT. Central Square, here almost hidden by the trees, was later renamed Pershing Square. In the foreground we see the First Methodist Church spire and the Auditorium at extreme right. Across the square we see the pointed roof of the St. Paul's Episcopal Church, which was torn down in the 1920s to make room for the Biltmore Hotel. (Published by Western Pub. & Novelty Co., Los Angeles.)

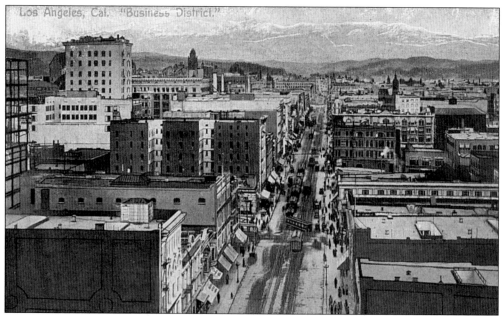

Los Angeles, Cal. "Business District."

LOS ANGELES, BUSINESS DISTRICT. Looking north to the mountains, this view shows Main Street from south of Fifth. At the far left, a new building is being erected at Spring Street, which was the heart of the financial district in the early 1900s. The tallest building in the picture is the Hibernian Building, which is still standing today at Fourth and Spring. The current business district is primarily on Flower Street. (Published by Newman Post Card Co., Los Angeles.)

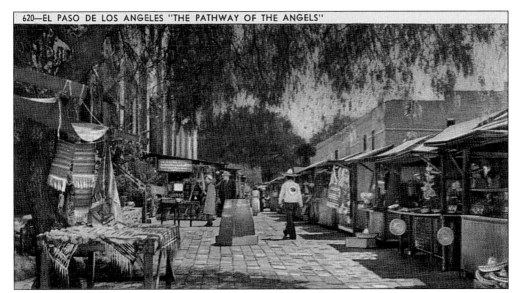

EL PASO DE LOS ANGELES...OLVERA STREET. Bounded by Sunset Boulevard and Spring Street, Arcadia and Alameda Streets, this is the founding site of the city of Los Angeles. It is made up of a plaza, Olvera Street, a park, and 27 historic or architecturally important buildings. Olvera Street runs off the old Plaza, once the scene of "lawless L.A." Since its restoration in 1930 in the style of a Mexican marketplace, its shops sell Mexican dresses, leather baraches, piñatas, and food. Several Mexican festivals occur here at various time of the year. (Published by Longshaw Card Co., Los Angeles.)

LA-103 BROADWAY SOUTH FROM FIFTH STREET, LOS ANGELES, CALIFORNIA

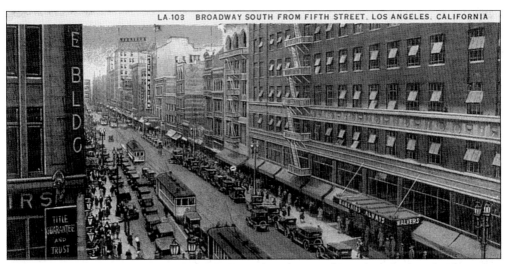

BROADWAY SOUTH FROM FIFTH STREET. Considered one of Los Angeles' main shopping streets, Broadway's crowded sidewalks and exotic sounds and smells have always given it an intense, urban quality much like New York's Broadway. Deteriorated since the war, however, it no longer is the "Great White Way" of the West. Many facades now are covered with plastic signs, and sidewalk ornaments are crooked and dirty. This view of an earlier time shows Walker's Department Store (later the Fifth Street Store) on the right. Walker's was known as the place to find a real bargain. (Published by Western Publishing and Novelty Co., Los Angeles.)

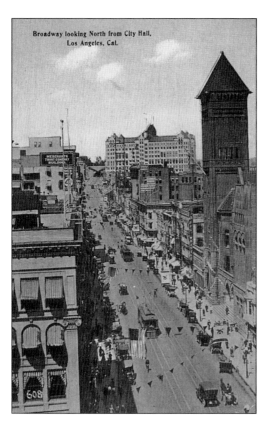

Broadway looking North from City Hall,
Los Angeles, Cal.

BROADWAY LOOKING NORTH FROM CITY HALL. The City Hall is the large building with the tower on the right. Those familiar with old Los Angeles should note the "Pig 'n Whistle" sign adjacent to City Hall. Pig 'n Whistle restaurants were classy places to have lunch and were famous for their desserts. Farther north on Broadway one sees the Chamber of Commerce Building, and at the top of the picture, the Hall of Records and the Broadway Tunnel. (Published by Western Publishing & Novelty Co., Los Angeles.)

SEVENTH STREET WEST FROM BROADWAY. Seventh and Broadway saw more pedestrian traffic than any other intersection in Los Angeles for many years. This view looking west on Seventh Street shows a corner of Bullock's on the right. Loew's State Theatre is on the left, and the Warner Bros. sign can be seen at Hill Street one block west. Seventh was a street of fine stores and amusements— the destination of many a suburbanite. (Published by Western Publishing & Novelty Co., Los Angeles.)

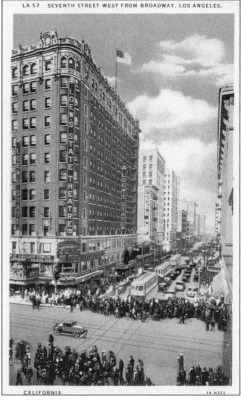

LA 57 SEVENTH STREET WEST FROM BROADWAY, LOS ANGELES,

CALIFORNIA

Broadway, South from Eighth Street.
On the right under the flag is the May Company, successor to Hamburger's; one block south at Ninth is Eastern-Columbia, a general department store. The large *Examiner* sign is seen in the far distance, located at Broadway and Eleventh. The *Herald Examiner* building was designed in 1912 by Julia Morgan, who also designed the Hearst Castle at San Simeon. Theaters noted here are, at lower left, the President, showing Sylvia Sidney in "Street Scene," and at lower right a theater showing a Tallulah Bankhead movie. (Published by Western Pub. & Novelty Co., Los Angeles.)

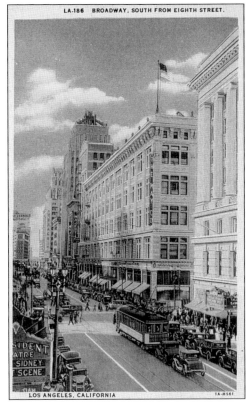

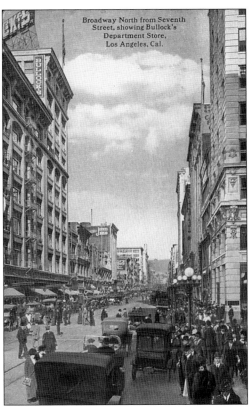

Broadway North from Seventh Street, Showing Bullock's Department Store.
Another view of Seventh and Broadway shows an earlier time. Everyone dressed up to go downtown in those days. Bullock's is on the left, and a new Bank of America is on the right. Farther north we see the Orpheum Theatre, famous in the old days for vaudeville. In the distance at center, a Coca-Cola sign adorns the side of a building. (Published by Western Publishing & Novelty Co., Los Angeles.)

13

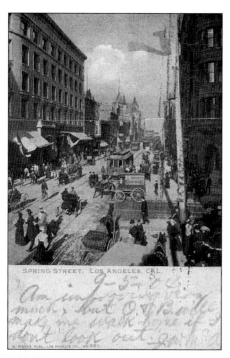

SPRING STREET. Once called "the Wall Street of the West," Spring Street is a National Register Historical District. It contains a treasury of historical buildings from 1900 to 1930, many of which have been refurbished. This view, probably about 1900, looks north from Third Street. Streetcars and horse-drawn vehicles prevail. The building on the right is the Henne Building. (Published by M. Rieder, Los Angeles. Card sent 1904.)

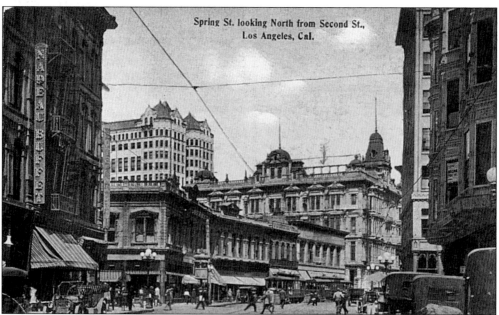

SPRING STREET LOOKING NORTH FROM SECOND STREET. The Hall of Records can be seen in the center distance in this view of Second and Spring. Two famous old hotels are in the picture: the Nadeau Hotel at left (the sign reads "Nadeau Buffet") and the Hollenbeck Hotel across the street. The block of two-story buildings in the center was later removed to make way for the *Los Angeles Times*, and the hotel beyond it at First Street was replaced by the new State Building. (Published by Western Publishing & Novelty Co., Los Angeles. This card was sent in 1913.)

SPRING STREET LOOKING NORTH FROM FIFTH. This busy street is shown with the Hibernian Bank in close-up. We see Tufts Lyon and Frederick's at near right and the Henne Office Building at left distance. As usual the sidewalks are thronged with pedestrians, trolleys line up in the street, and automobiles are parked at the curb. This card was mailed in 1913. (Published by Western Publishing & Novelty Co., Los Angeles.)

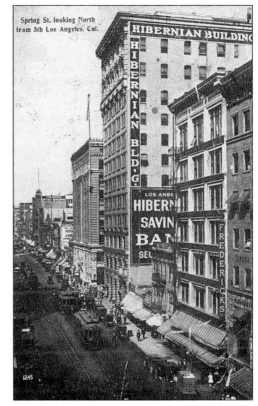

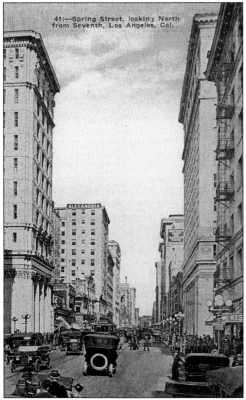

SPRING STREET LOOKING NORTH FROM SEVENTH. A microcosm of city life can be viewed here. The vehicular traffic is exclusively automotive, with at least a half-dozen designs of cars on the street. Pedestrians come in crowds—business is good. Street lighting is new and attractive. Hotels and banks abound. The Alexandria Hotel looms on the left at the corner of Spring and Fifth, with the Security Trust and Savings Bank across the street. The year appears to be about 1920. (Published by M. Kashower Co., Los Angeles.)

15

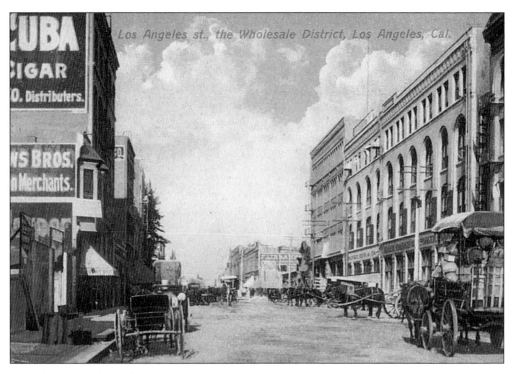

Los Angeles st., the Wholesale District, Los Angeles, Cal.

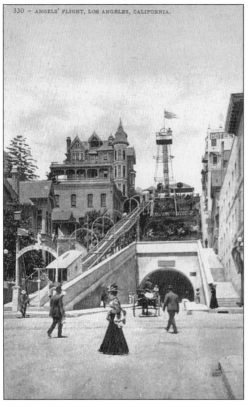

330 – ANGELS' FLIGHT, LOS ANGELES, CALIFORNIA.

LOS ANGELES STREET, THE WHOLESALE DISTRICT. The wholesale district is what makes a city function. This view shows Los Angeles Street one block east of Main. All the vehicles appear to be horse drawn, thus dating the picture to about 1905. The market that handled the produce, brought into the city daily, was several blocks to the east. (Published by M. Rieder, Los Angeles.)

ANGELS' FLIGHT, LOS ANGELES. Located between Grand, Hill, Third, and Fourth Streets, Angels' Flight is a 315-foot railway that transports riders from Hill Street up the hill to the Bunker Hill area. Billed as "the shortest railway in the world," it was installed in 1901 so the inhabitants of the posh neighborhood on the top of the hill need not climb stairs. After the community declined and became an eyesore, the rail service was discontinued; however, as Bunker Hill became a modern office complex, Angels' Flight was reinstalled in 1996. (Published by Edward H. Mitchell, San Francisco. Card was mailed in 1911.)

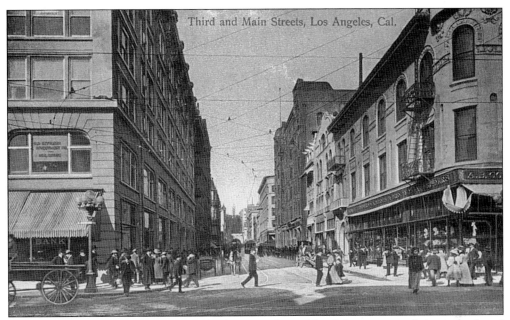

THIRD AND MAIN STREETS. This view looks west down Third Street toward the tunnel and Angels' Flight in the far distance. The center of downtown here shows the usual confluence of banks, lawyers' offices, shopping emporiums, and the constant stream of interested persons doing the business of the day. A.B. Cohn Bros. is at the right. The length of the ladies' dresses indicate a date *c.* 1905. (Published by M. Rieder, Los Angeles.)

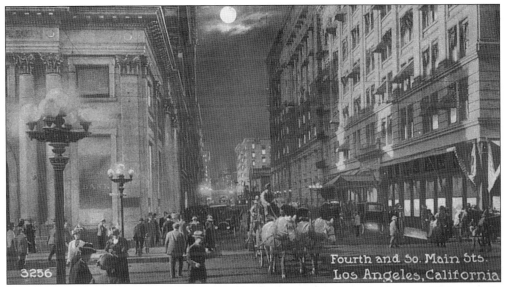

FOURTH AND MAIN STREETS. A night scene looking west on Fourth Street at Main reveals a branch of the Farmers and Merchants National Bank at left. On the right, the Van Nuys Hotel, later to become the Barclay, occupies the corner. The Westminster Hotel was directly across the street. The message on the back of the postcard says, "This is the poorest street in town. Broadway, Spring, and Hill are much better than Main." The time is about 1908. (Published by Edward H. Mitchell, San Francisco.)

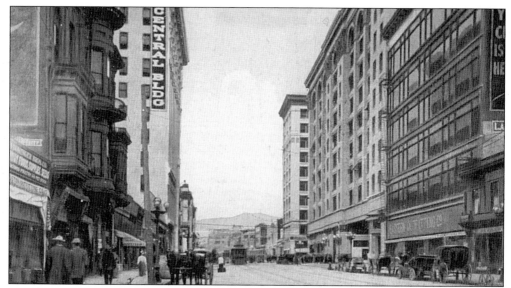

MAIN STREET LOOKING NORTH NEAR SIXTH STREET. Sixth and Main are in the center of the downtown business and shopping district, with most of the stores along Main being discount and wholesale emporiums. On the right one sees the Western Outfitting Co., and across the street the Boston Outfitting Co. The large building right-center is the Pacific Electric Building. On the street the transport is predominantly horse-drawn, though one automobile is parked at the curb on the right. Appearing in the distance are the San Gabriel Mountains. (Published by the O. Newman Co., Los Angeles.)

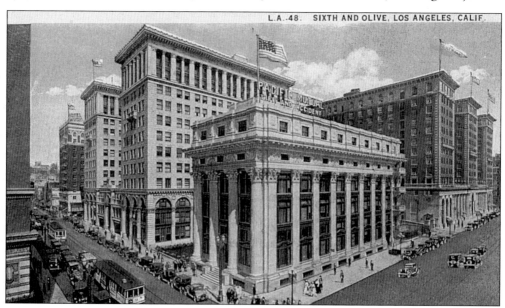

SIXTH AND OLIVE. This view from Sixth and Olive Streets shows the buildings on the west side of Pershing Square. The Biltmore Hotel is at the far right; the Pacific Mutual Life Insurance Building is on the corner; and at the far left we see the Hotel Savoy at the corner of Sixth and Grand. Beyond the Savoy several old used book stores occupied the north side of Sixth Street. Published by Western Publishing & Novelty Co., Los Angeles.)

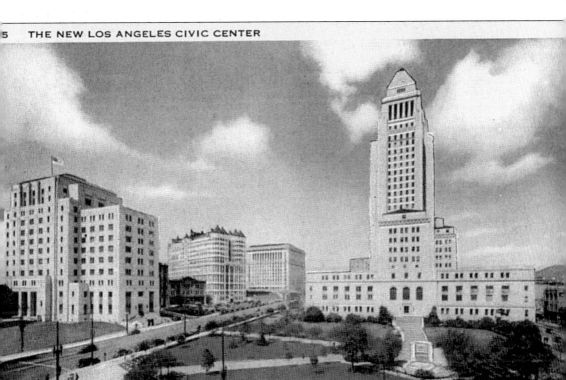

THE NEW LOS ANGELES CIVIC CENTER. Los Angeles has the second largest governmental center in the United States outside of Washington D.C. After working hours it becomes rather lifeless because about 200,000 people who work here in the daytime scatter to their suburban homes at night. The buildings are bounded by Temple, Main, First, and Grand Streets. City Hall is at right, Hall of Justice at center, Hall of Records center left, and State Building at left. (Published by Longshaw Card Co., Los Angeles.)

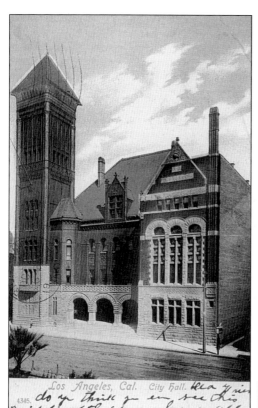

LOS ANGELES CITY HALL. This impressive building is seen in many early Los Angeles postcard pictures. Its tower was a landmark in the city for many years, visible from every perspective. It was located on Broadway between Second and Third. The card was mailed in 1907. (Published by Paul Koeber Co., New York City.)

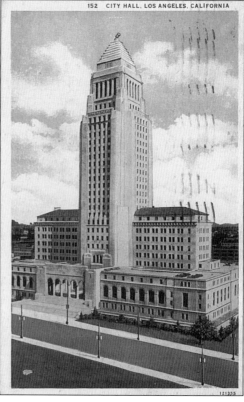

CITY HALL, LOS ANGELES. Located at 200 N. Spring Street, the City Hall, built in 1928, was the tallest structure in the downtown area until 1957. It is 32-stories high and a block long; all other buildings were limited to 12 floors. Today there are taller buildings, but City Hall's distinctive tower is one of Los Angeles' most familiar landmarks. The interior is decorated with eight figures showing the building's main concerns: education, health, law, art, service, government, protection, and trust. This card was mailed in 1931. (Published by Western Publishing & Novelty Co., Los Angeles.)

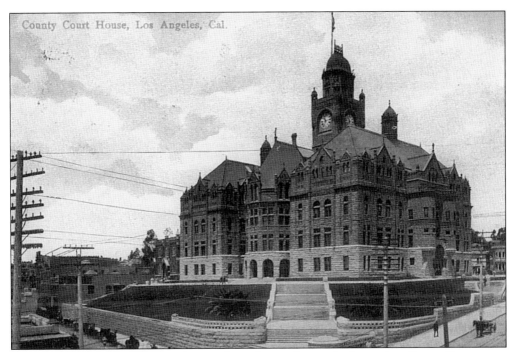

COUNTY COURT HOUSE. Located Temple and Broadway, the imposing Court House was built of red sandstone and sat on top of an elevation overlooking the city. Emulating much Victorian architecture, the building was castle-like in its heavy stone materials and its tower. The card was mailed in 1908. (Published by I. Stern, New York.)

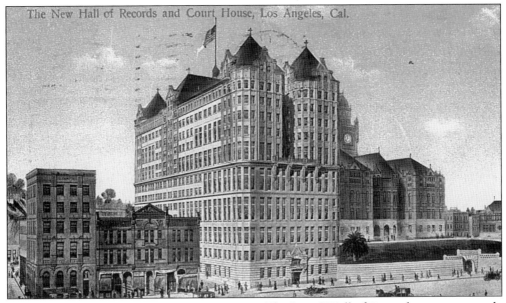

THE NEW HALL OF RECORDS AND COURT HOUSE. The "new" Hall of Records was apparently under construction when this postcard was sent in 1910. The correspondent says, in part: "…This is the way she will look when finished up." It was located at Broadway and Court Street. (Published by Geo. O. Rested, Los Angeles.)

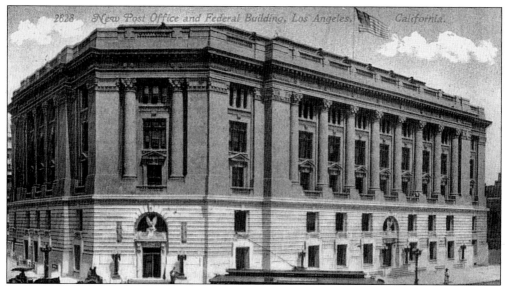

NEW POST OFFICE AND FEDERAL BUILDING. In spite of its designation as new, this post office did not remain so for long. Built in the early 1900s, it was bounded by Spring, Temple, and Main Streets, and was superceded within a quarter of a century by a newer Federal Building erected on the north side of the new City Hall. This card was mailed in 1912. (Published by Edw. H. Mitchell, San Francisco.)

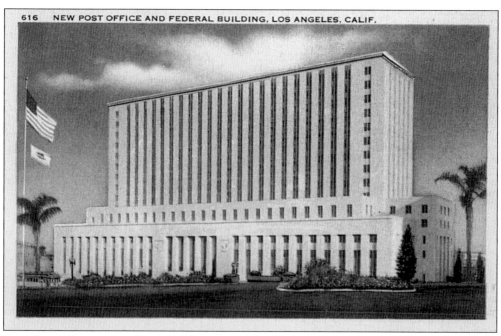

NEW POST OFFICE AND FEDERAL BUILDING. The United States Post Office and Federal Court Building occupies the block directly north of the City Hall. It is an impressive addition to the Civic Center and houses all of the U.S. District Courts and Federal Departments. It is located below Temple Avenue and between Spring and Main Streets. (Published by Longshaw Card Co., Los Angeles.)

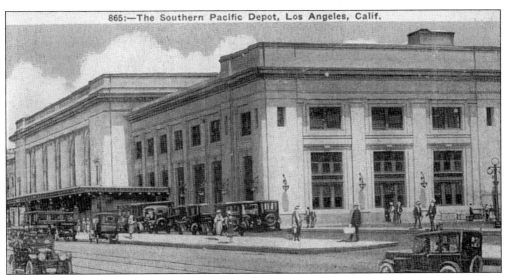

865:—The Southern Pacific Depot, Los Angeles, Calif.

THE SOUTHERN PACIFIC DEPOT. In the days before the Union Station was built, three railroad depots served the Los Angeles area. This postcard shows the Southern Pacific Depot, whose passenger trains first served the Pacific Coast in 1876. Especially popular was the Daylight Limited, which ran the Los Angeles-San Francisco route along the coast, while such trains as the Owl and the Lark traveled up the San Joaquin Valley. (Published by M. Kashower Co., Los Angeles.)

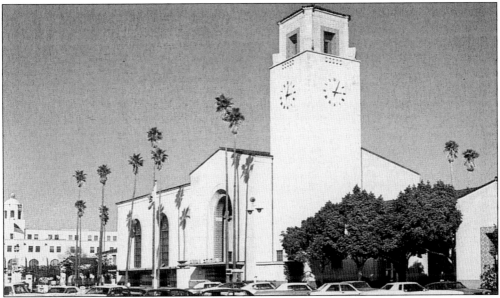

UNION STATION. This beautiful railroad depot, opened in 1939, was the last passenger terminal to be built in the United States. It is jointly owned by the Southern Pacific, Santa Fe, and Union Pacific railroads. Designed with Spanish mission, Moorish, and modern style elements, it contains a concourse with a 52-foot-high ceiling. It is located at 800 N. Alameda Street, opposite the El Pueblo de Los Angeles Historic Park. The site is the original location of Chinatown, which was moved three blocks north to accommodate this building. (Published by Orange Empire Railway Museum, Perris, CA.)

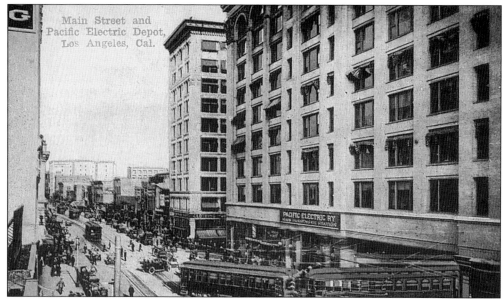

Main Street and Pacific Electric Depot. The Pacific Electric Building (originally the Huntington Building) opened January 15, 1905, amid much fanfare and a parade of trolleys. It was located at Sixth and Main, at that time a residential area, and at nine stories was the tallest building in Los Angeles. From this building Henry Huntington's fleet of big red trolleys emerged to change forever transportation in Los Angeles. (Published by Souvenir Publishing Co., Los Angeles.)

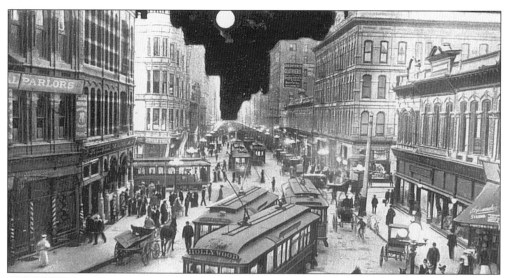

Spring Street. The electric trolley system of Los Angeles was developed by Henry E. Huntington between 1900 and 1910. It covered more than 1,000 miles, extending to San Fernando (north), Riverside (east), Newport Beach (south), and to the ocean (west). Six hundred cars carried 225,000 people 73,000 miles daily. Residents and tourists alike used the red car system generously, often chartering private cars for moonlight rides and picnics. Here we see a busy Spring Street on a moonlit night. (Published by the Newman Co., Los Angeles.)

CHAMBER OF COMMERCE BUILDING. In 1910 the Chamber of Commerce Building stood at 126 S. Broadway in a block that now houses the *Los Angeles Times*. At the left of the central doorway we see a bank, and to the right of the awning we see another doorway next to a window with a huge sign which reads "Herald." A strip across the window says, "How far will the squirrel travel?" The building is a handsome example of turn-of-the-century architecture. The flag on top is flying at half-mast. (Published by Paul C. Koeber Co., New York City.)

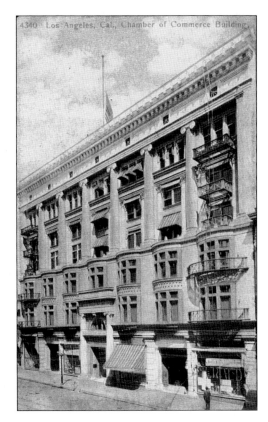

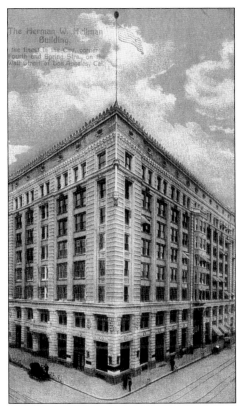

THE HERMAN W. HELLMAN BUILDING. For nearly 100 years the Hellman Building has stood on the northeast corner of Fourth and Spring Streets, deep in Los Angeles' "Wall Street" district. The building has been home to banks for most of those years. Situated next door, though not seen in the picture, was the Van Nuys Hotel at Fourth and Main. (Published by the Newman Co., Los Angeles.)

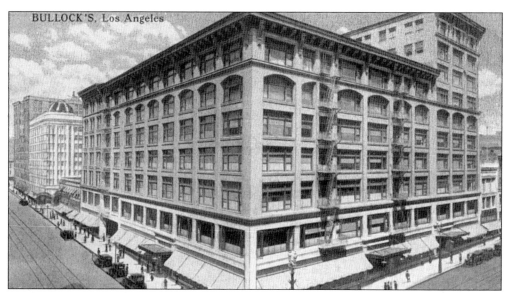

BULLOCK'S. This view of Bullock's Department Store looks to the left down Seventh Street from the corner of Broadway. Men's furnishings were at the second entrance. The building with the dome at the corner of Hill Street housed the Warner Brothers Theatre, with the entrance at the corner. Bullock's is no longer in business, and the building is now occupied by the Los Angeles Jewelry Mart. (No publisher given.)

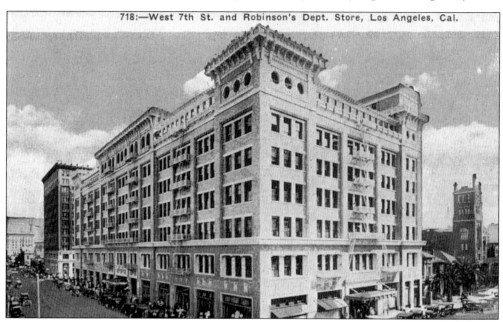

718:—West 7th St. and Robinson's Dept. Store, Los Angeles, Cal.

WEST SEVENTH STREET AND ROBINSON'S DEPARTMENT STORE. The finest shops and luncheon spots for the throngs that would come into the city each day on the big red streetcars were found on West Seventh. This view shows J.W. Robinson's store, one of the classier places to buy, located on the south side of Seventh between Grand and Hope. It is now a telecommunications building. To the left at Grand Avenue is J.J. Haggerty Co., a women's specialty store of the finest quality. (Published by M. Kashower Co., Los Angeles.)

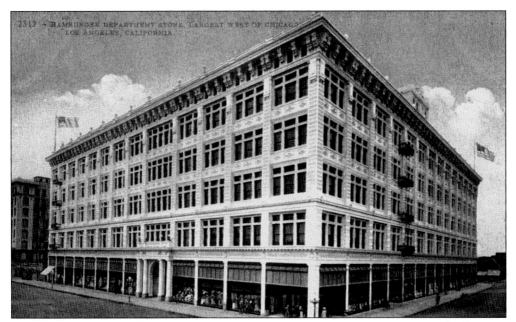

HAMBURGER'S DEPARTMENT STORE. "The largest department store west of Chicago" occupied most of the block on the south side of Eighth Street between Broadway and Hill. Just a block from Bullock's, Hamburger's added to the shopping pleasures of thousands of Los Angeles residents for decades. It later became the May Company. (Published by Edw. H. Mitchell, San Francisco.)

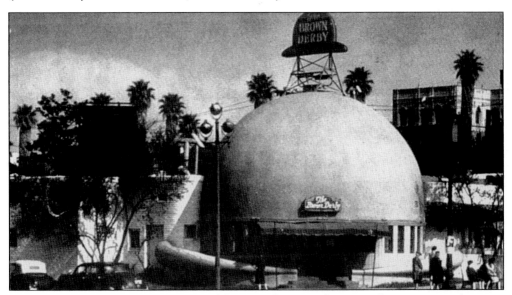

THE BROWN DERBY RESTAURANT. One of the most famous of Los Angeles restaurants because of its Hollywood connections, the Brown Derby is located at 3377 Wilshire Boulevard. Its unique shape and much-advertised ambiance have made it known the world over. Though it has several locations throughout the area, the original establishment is at the Wilshire Boulevard location. When the hat-shaped building was threatened with demolition, preservationists and developers compromised. (Published by Mike Roberts, Berkeley, CA.)

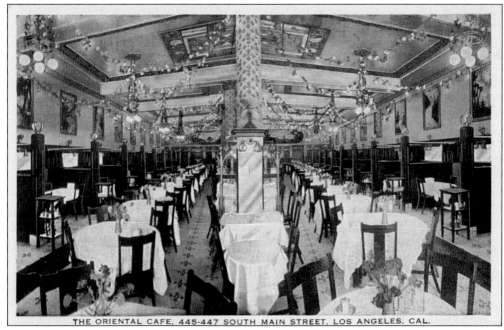

THE ORIENTAL CAFÉ. This advertising postcard points out only major assets of the Oriental Café. Located at 445–447 S. Main Street, next to the new Rosslyn Hotel, it was in the downtown business area. It had "cuisine without equal," "service the best," and offered Chinese and American dishes. The picture reveals an attractive moderate-sized room with many small tables for four, all with flowers. It also claimed to be "the finest on the coast." (Published by Geo. Rice & Sons, Los Angeles.)

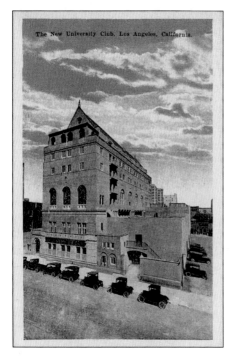

THE NEW UNIVERSITY CLUB. This home of the University Club stood on the northeast corner of Wilshire and Hope. The club traded the building to Lincoln Savings and Loan for a long-term lease of two floors in a new building on the southeast corner of Sixth and Hope. The first building was torn down in the mid-1960s for a parking lot. The club itself no longer exists. (Published by California Postcard Co., Los Angeles.)

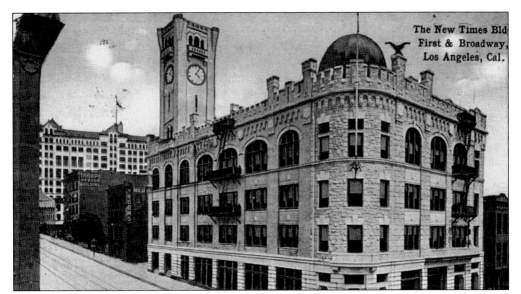

THE NEW TIMES BUILDING. The *Los Angeles Times* Building was situated on the northeast corner of First and Broadway. This postcard, sent in 1914, reflects a time several years after the disastrous explosion of October 1, 1910. Two unionists set off a bomb that killed 20 workers and caused a scandal considered then to be "the crime of the century." Although the perpetrators were arrested and jailed, there was bitterness between union and non-union employees that went to the highest levels. General Harrison Gray Otis was the editor during this difficult period. (Published by Western Publishing & Novelty Co., Los Angeles.)

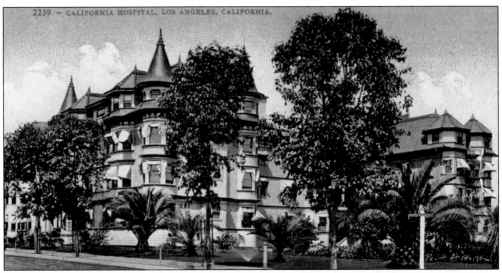

CALIFORNIA HOSPITAL. Over 100 years of history are built into California Hospital, now California Hospital Medical Center. Still in use are major portions of the original structure, the building having been enlarged and modernized through the years. This original picture shows a Gothic-Victorian castle whose architecture is keeping with the style of the turn of the century. It is located at 1401 S. Grand Street. (Published by Edw. H. Mitchell, San Francisco.)

29

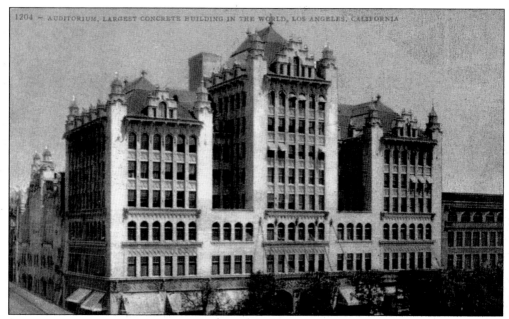

AUDITORIUM, LARGEST CONCRETE BUILDING IN THE WORLD. For many years the Philharmonic Auditorium was home to all major musical events in the city. Located on the northeast corner of Fifth and Olive, this massive tri-partite structure claimed to be the "the largest concrete building in the world." It was built on the site of Hazard's Pavilion, a great barn of a place, which had been the first center of culture in Los Angeles. (Published by Edw. H. Mitchell, San Francisco. Card was sent in 1909.)

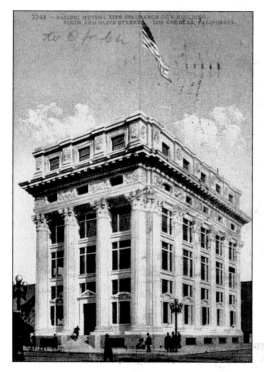

PACIFIC MUTUAL LIFE INSURANCE COMPANY'S BUILDING. A close-up of the Pacific Mutual Building shows a clean classic design. The four columns faced Sixth Street; the long side faced Olive. Just to the right (out of the picture) was the Biltmore Hotel's future location, and across the street was Central Square, later called Pershing Square. This postcard was mailed in 1911. (Published by Edw. H. Mitchell, San Francisco.)

30

Two
HOTELS

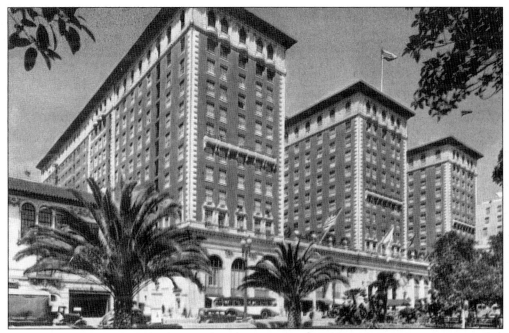

THE BILTMORE HOTEL. "The largest hotel in western America" has 1,500 rooms and is situated between Fifth, Olive, and Grand Streets, opposite Pershing Square in the heart of downtown. Built in 1923 in Italianate Beaux-Arts style, it has long been one of Los Angeles' most luxurious hotels; its supper clubs and restaurants are a noted rendezvous of celebrities and movie stars. The Olive Street entrance leads into a dazzling court which is especially impressive. (No publishing information.)

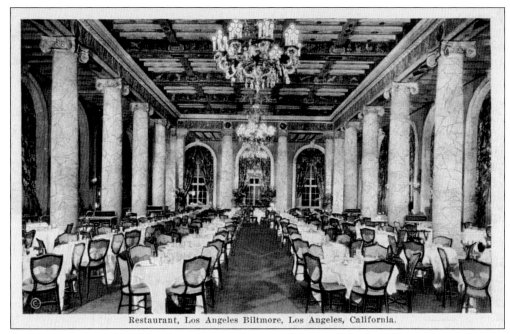

Restaurant, Los Angeles Biltmore, Los Angeles, California.

RESTAURANT, LOS ANGELES BILTMORE. Reflecting the word "palatial" used so often in describing the Biltmore, the dining room is intimidating by its size and heavy columns. The massive chandeliers and Sheraton furniture lend elegance to the decor. The Biltmore Bowl supper club is also palatial in size, seating 1,500 patrons. (Published for the Gittleson Bros., Los Angeles.)

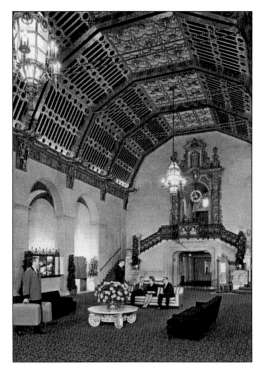

LOS ANGELES BILTMORE. In the Los Angeles Biltmore, the public rooms echo the elegance, size, and luxury supplied throughout. The Renaissance decor in this foyer is especially grandiloquent. There is also an exhibition hall measuring 16,900 square feet, and parking garages which accommodate 4,000 cars. (Published by Hannau-Robinson, Orlando, FL.)

ALEXANDRIA HOTEL. Downtown's first luxury hotel, the Alexandria was built in 1906, occupying the corner at Fifth and Spring Streets. The first Academy Awards were held here in 1927, when Janet Gaynor and Emil Jannings were the recipients for Best Acting, and *Wings* won for Best Picture. Throughout, the facilities typify late Victorian beauty and elegance. (Published by the Los Angeles News Co., Los Angeles.)

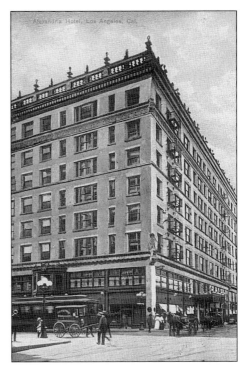

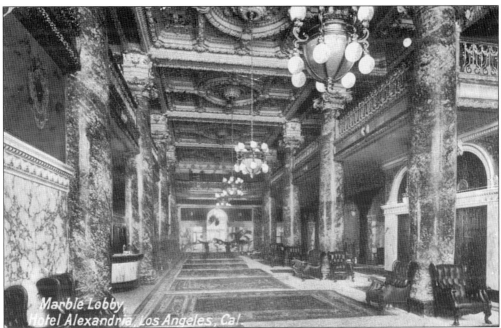

MARBLE LOBBY, HOTEL ALEXANDRIA. The lobby of the Alexandria is overwhelming with its gigantic marble columns, Oriental carpets, and low-hanging chandeliers. At the far end one comes to the legendary Palm Court. Elsewhere is the Peacock Tea Room, long a popular gathering place. Many elegant events have taken place here since 1906. (Published by the Newman Company, Los Angeles.)

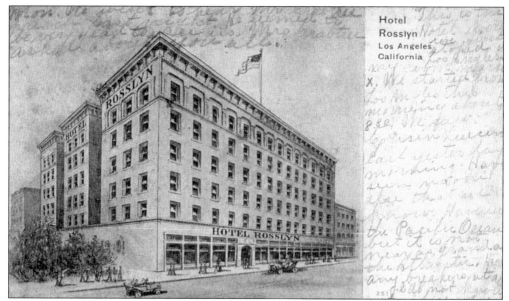

HOTEL ROSSLYN. Located at Fifth and Main Streets, the Rosslyn Hotel was built before 1907, when this card was mailed. A later addition was built across Fifth Street to the south, and connected to the hotel by means of a marble tunnel. With the new addition, the Rosslyn numbered 1,100 rooms and 800 baths. (Published by Wood's Post Cards, Los Angeles.)

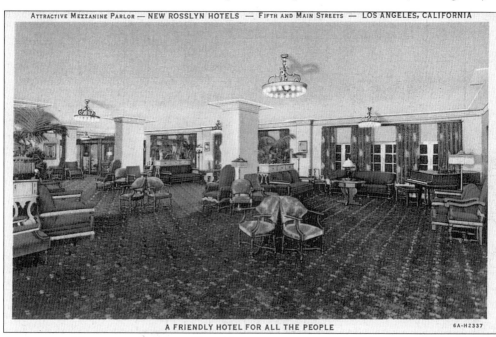

ATTRACTIVE MEZZANINE PARLOR, NEW ROSSLYN HOTELS. Furnishings in the Rosslyn mezzanine indicate that this hotel was a popularly priced place which was homey and comfortable. Amenities here include a grand piano. It advertised that a free auto bus met all trains, and that there was an automobile entrance direct to the hotel lobby. (Published by Curt Teich & Co., Chicago.)

34

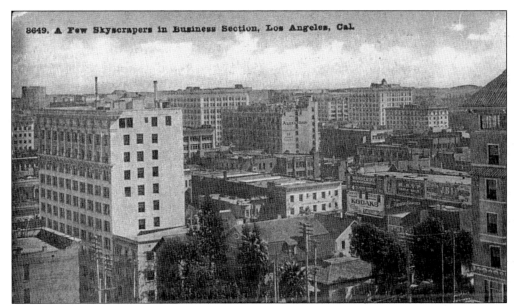

8649. A Few Skyscrapers in Business Section, Los Angeles, Cal.

A FEW SKYSCRAPERS IN BUSINESS SECTION. This view of downtown Los Angeles looking southeast from the location of Angels' Flight shows the Alexandria Hotel at Fifth and Spring in the center of the picture. The Fremont, a residential hotel on Bunker Hill, is on the extreme right with an unparalleled view of the city below. (Published by the California Postcard Co., Los Angeles.)

THE LOS ANGELES MAYFLOWER HOTEL. Located on South Grand Avenue between Fifth and Sixth, the Mayflower Hotel is now the Checkers Hotel. In 1945 when this postcard was mailed, the Mayflower advertised as follows: "Los Angeles' newest and most centrally located downtown hotel. Directly across from the Biltmore—adjoining beautiful Library Park. Three-hundred and fifty rooms with bath—all outside exposure. $2.75, $3.50, $3.85, $4.40. One or two persons." (Published by the Kayco, Los Angeles.)

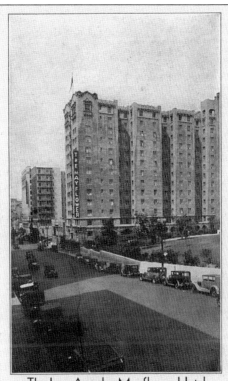

The Los Angeles Mayflower Hotel

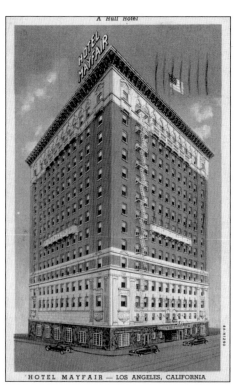

HOTEL MAYFAIR — LOS ANGELES, CALIFORNIA

HOTEL MAYFAIR. A typical advertising postcard of the 1930s shows the Mayfair as a red-brick rectangular structure "in downtown Los Angeles" located at Seventh and Witmer Streets. It presented its "World Famous Rainbow Isle" as an outstanding extra. Apparently it did not claim to be fireproof. Its fire escape ladders from top floor to street are especially noticeable. (Published by Curt Teich, Chicago.)

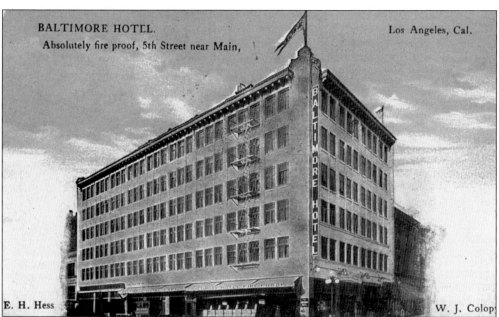

BALTIMORE HOTEL.

Absolutely fire proof, 5th Street near Main,

Los Angeles, Cal.

E. H. Hess

W. J. Colopy

BALTIMORE HOTEL. Advertising itself as "absolutely fireproof," the Baltimore Hotel was located on East Fifth Street near Main. A modest hotel, it was the destination of many winter visitors in the early years. It is ironic that the Baltimore should suffer a $500,000 fire in 1990; it was vacant and about to be renovated for low-income housing. This card shows it in 1914, when the card was sent. (Published by E.H. Hess & W.J. Colopy.)

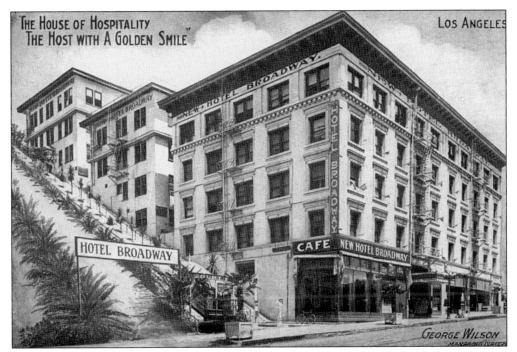

HOTEL BROADWAY. Located in the Civic Center opposite the Hall of Records and Courthouse, Hotel Broadway claimed to offer "comfort without extravagance" it its 350 rooms. On the European plan, it was near the finest Broadway shopping. It offered a free autobus to meet all trains. All this cost $1.00 per day—and up. (No publisher given.)

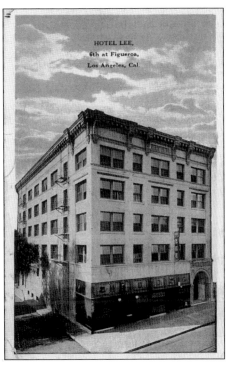

HOTEL LEE. Occupying a corner at Sixth and Figueroa, Hotel Lee presents an unprepossessing appearance. Only five-stories high and located five blocks west of the main business area of downtown, it was probably a hotel for traveling salesmen or transients. The postcard was sent in 1926 by a correspondent who said, "Spent Sat. and Sun. at this place—enjoyed it so much here...I have had a wonderful trip." (Published by E.C. Kropp, Milwaukee.)

37

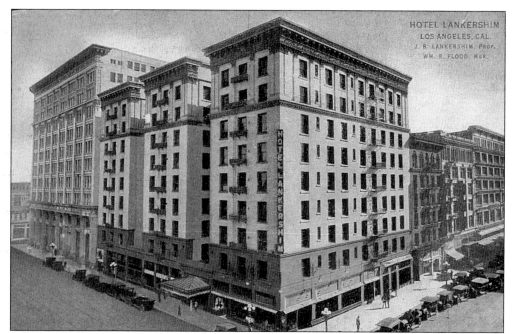

HOTEL LANKERSHIM. One of Los Angeles' large commercial hotels in the downtown area, Hotel Lankershim was located at Seventh and Broadway. This scene includes a portion of Broadway looking south to the right; Spring Street and the financial district are off to the left. From the cars parked at the curb, it would appear to be early in the 1920s. (No publisher given.)

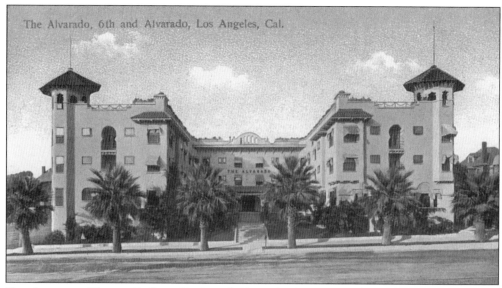

THE ALVARADO HOTEL. Built at Sixth and Alvarado Streets on the east side of Westlake Park, the Alvarado was famous for "the stately palms—most beautiful in California." A row of palms extended the length of the hotel in the parkway along Alvarado Street. The lake in Westlake Park was popular as a recreational spot for boating. (Published by M. Rieder, Los Angeles.)

HOTEL STILLWELL. Located on Grand Avenue between Eight and Ninth, the Stillwell is an old hotel which is rather plain but gives the appearance of practicality and convenience. Its 232 rooms offer the major amenities. Even though advertised as fireproof, its fire escape ladders are impressive. (Published by E.C. Kropp, Milwaukee.)

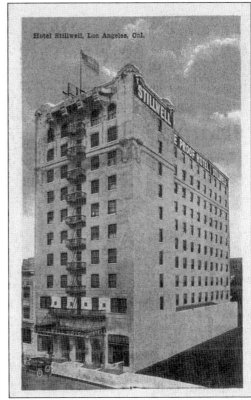

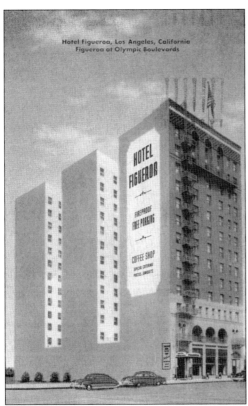

HOTEL FIGUEROA. This "friendly" hotel was originally a YWCA. Its 285 rooms are decorated in Spanish colonial, with wildly designed hand-painted doors, elevators, and ceilings, and attended by huge potted plants and much wrought iron. It is located at 939 S. Figueroa Street at Olympic Boulevard. In 1951 when this card was sent, the advertising boasted of 400 newly decorated, comfortable, outside rooms, new coffee shop, dining room, and free parking. (Published by MWM, Aurora, Missouri.)

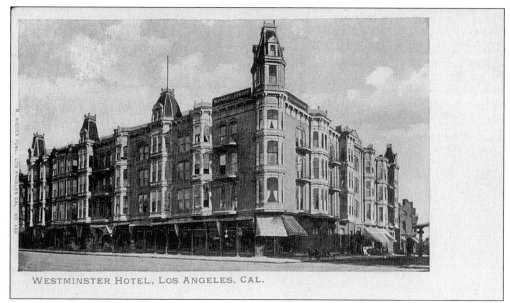

WESTMINSTER HOTEL, LOS ANGELES, CAL.

WESTMINSTER HOTEL. A grand old hotel built before 1890, the Westminster survived past the middle of the 20th century. It was on the northeast corner of Fourth and Main Streets, and was eventually torn down and replaced by a parking lot. Many of the rooms had bay windows, and the hallways were exceptionally wide. It was a good example of now-vanished Victorian elegance. (No publisher given.)

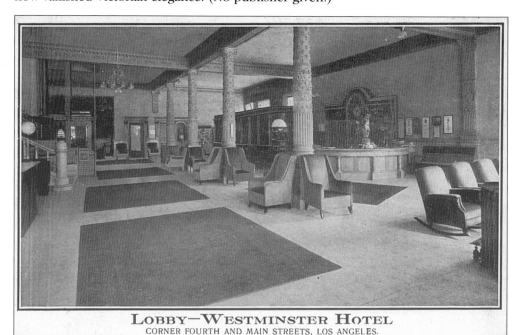

LOBBY—WESTMINSTER HOTEL
CORNER FOURTH AND MAIN STREETS, LOS ANGELES.

WESTMINSTER HOTEL. This spacious lobby graced the old Westminster Hotel on the corner of Fourth and Main. The wide staircase seen at the left was marble, and marble pillars extended the length of the lobby. This hotel was directly across the street from the Van Nuys Hotel, which later became the Barclay Hotel. (No publisher given.)

40

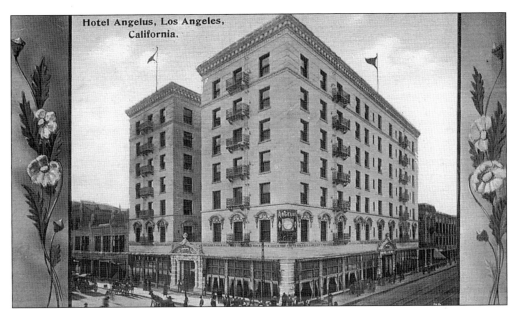

Hotel Angelus, Los Angeles, California.

HOTEL ANGELUS. In the heart of downtown Los Angeles, Hotel Angelus is shown here on the corner of Fourth and Spring Streets. An attractive building with a massive classical entrance on each street, it is supplied with numerous fire escape ladders attached to balconies on each of its six above-street floors. Pedestrians indicate a busy street corner about 1907. (Published by Tichnor Bros., Los Angeles.)

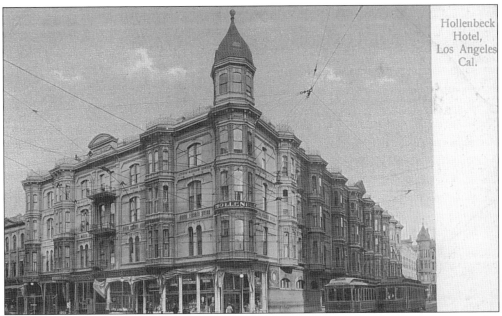

Hollenbeck Hotel, Los Angeles Cal.

HOLLENBECK HOTEL. Built before 1890, the Hollenbeck was one of the most popular hotels in the city. It stood on the southwest corner of Second and Spring Streets, and was a favorite Los Angeles watering hole. It had its own cigar store and barber shop on the Second Street side. In the picture we see the big red trolley cars waiting to take tourists or travelers to Redondo. (Published by M. Rieder, Los Angeles.)

41

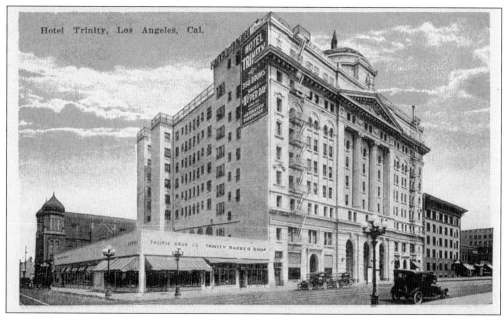

HOTEL TRINITY. Just south of downtown, Hotel Trinity was located at Ninth and Grand. Owned by Los Angeles Investment Company, it had 350 rooms and claimed to be absolutely fireproof. A handsome building, its architecture was noticeably classical in design. It had its own power, light, and cooling systems. Inside the building there was an auditorium seating 2,500 people with "one of the finest pipe organs in the west." Trinity later became the Embassy Hotel and Auditorium. (Published E.C. Kropp, Milwaukee.)

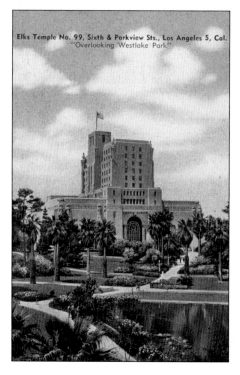

ELKS TEMPLE NO. 99. An advertising postcard lists advantages to "all Elks, their families, and friends": 160 deluxe hotel rooms for $2.50 single, $3.50 double; popular price coffee shop, cocktail lounge, swimming pool, and other club facilities. All this "overlooking Westlake Park" at Sixth and Parkview Streets. (Published by E.C. Kropp, Milwaukee.)

Three
Parks, Colleges, and Schools

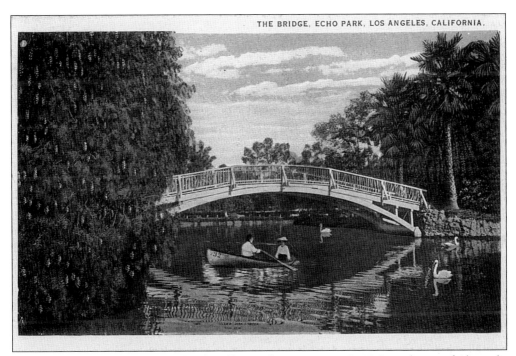

THE BRIDGE, ECHO PARK, LOS ANGELES, CALIFORNIA.

THE BRIDGE, ECHO PARK. North of Hollywood Freeway (U.S. 101) and east of Alvarado Street, Echo Park was laid out in 1890 by Joseph Henry Taylor to resemble an English garden. It serves during the summer as a focal point for various festivals presented by ethnic communities. The sender says, "Tonight we are going to see Charlie Chaplin in *The Gold Rush*. The picture was taken in the High Sierra Mtns." (Published by Western Publishing & Novelty Co., Los Angeles.)

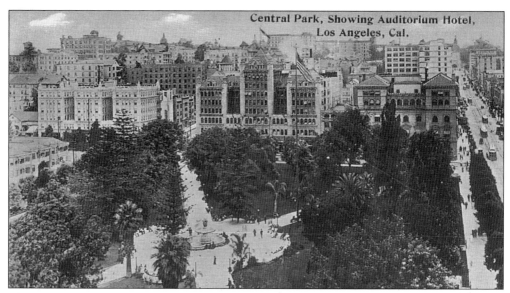

CENTRAL PARK, SHOWING AUDITORIUM HOTEL. Central Park (now Pershing Square) is located in the heart of downtown, circumscribed by Fifth, Hill, Sixth, and Olive Streets. Though landscaped in various ways since it was designated the city's first public park in 1866, it has afforded a delightful resting place for countless visitors. In 1918 it was named Pershing Square in honor of the great World War I General John J. Pershing. (No publisher given.)

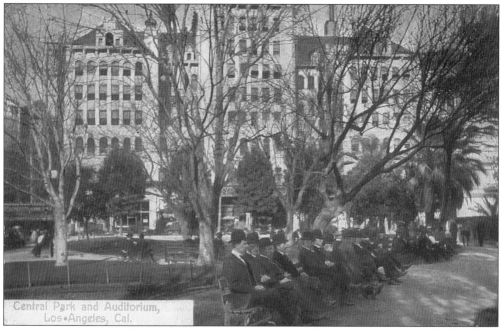

CENTRAL PARK AND AUDITORIUM. The many people sitting on the benches attest to the restfulness and peace offered by Central Park. The auditorium's concrete mass was only one such building near the park. In addition, there was to come the world's largest underground garage, which today accommodates over 2,000 cars. (Published by Newman Post Card Co., Los Angeles.)

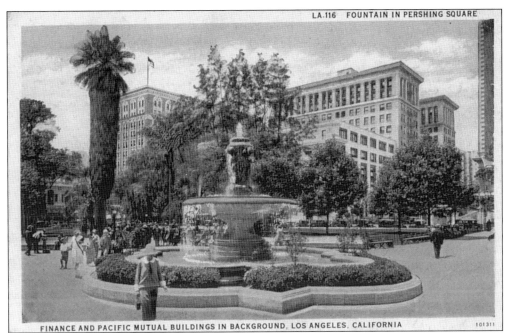

FINANCE AND PACIFIC MUTUAL BUILDINGS IN BACKGROUND, LOS ANGELES, CALIFORNIA

FOUNTAIN IN PERSHING SQUARE. A close-up of the single fountain in Pershing Square (Central Park) is shown here previous to a new landscaping of the park. Much landscaping was done through the years. The Finance and Mutual Buildings are in the background. This card was mailed in 1931, with only "Best wishes from your brother" as its message. (Published by Western Publishing & Novelty Co., Los Angeles.)

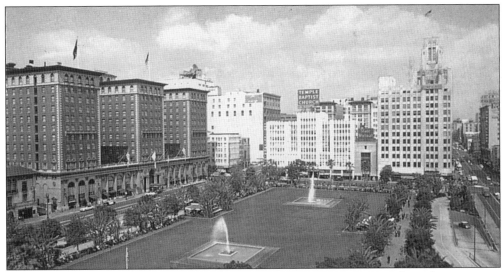

PERSHING SQUARE SHOWING BILTMORE HOTEL. A new landscaping of Pershing Square shows two fountains in a grassy sward. The trees and bushes of an earlier time have been removed. To the left we see the Biltmore Hotel. In the center the sign for the Temple Baptist Church tops the auditorium building. Hill Street is at extreme right. The Biltmore here faces Olive Street; it is a block wide and extends back to Grand Avenue. (Published by Western Publishing & Novelty Co., Los Angeles.)

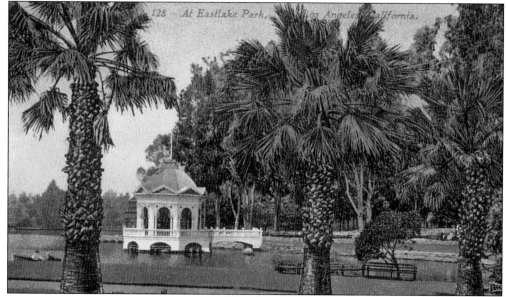

AT EASTLAKE PARK. Calm, tropical beauty is evident in this scene of boaters on the lake and picnickers on the grass amid palm trees. The correspondent who sent this card in 1914 said, in part, "I endorse all you said about people. It is their beautiful character we admire...I would be pleased to hold you by the hand if you could extend it over the valleys and mountains to the "Angle [*sic*] City" by the sea." (Published by the Edw. H. Mitchell, San Francisco.)

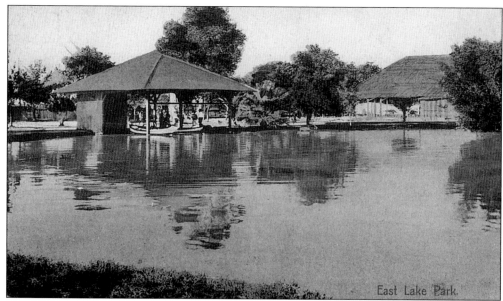

East Lake Park.

EAST LAKE PARK. Of the 60 acres in East Lake Park, 8 acres were covered by the lake itself. A very popular park situated on Mission Road, East Lake contained beautiful drives, a famous cacti garden of over 200 species, a conservatory, and a zoological garden. On Sundays and holidays, thousands of visitors were in attendance. This card was mailed in 1908. (Published by M. Reider, Los Angeles.)

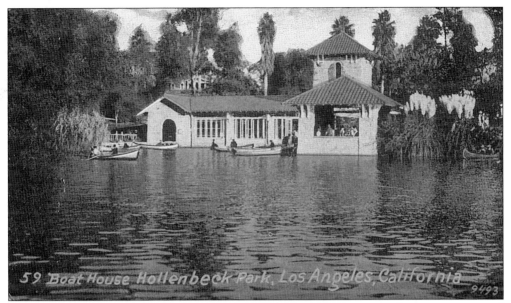

BOAT HOUSE, HOLLENBECK PARK. Just east of the downtown area between First and Fourth Streets, Hollenbeck Park offers many types of activities for many people. With a large lake and facilities for boating, it also provides a gathering place for family picnics and other outings. (Published M. Kashower Co., Los Angeles.)

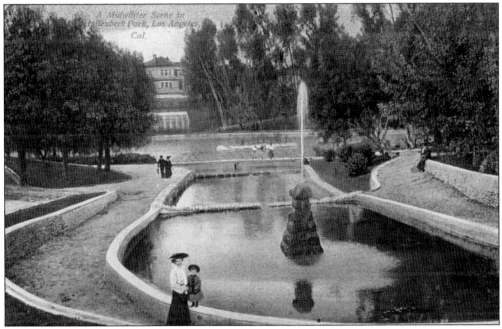

A MIDWINTER SCENE IN HOLLENBECK PARK. Mailed in 1909, this card says, "Surprised to get your card. This is Sunday morn—don't know what I'll do today. Come down and talk to me awhile. Let me hear from you often." It is difficult to see midwinter in this picture; however, one must remember it *is* California. (Published by Newman Post Card Co., Los Angeles.)

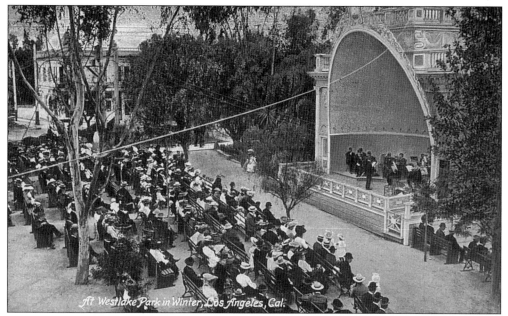

AT WESTLAKE PARK IN WINTER. This postcard was mailed in 1909, showing winter residents enjoying a band concert at the band shell in Westlake Park. After World War II the name was changed to MacArthur Park. It is west of downtown surrounded by many apartment houses and residential hotels. Wilshire Boulevard runs through MacArthur Park and a lake fed by a natural spring adds to the popularity of the place. (Published by Newman Post Card Co., Los Angeles.)

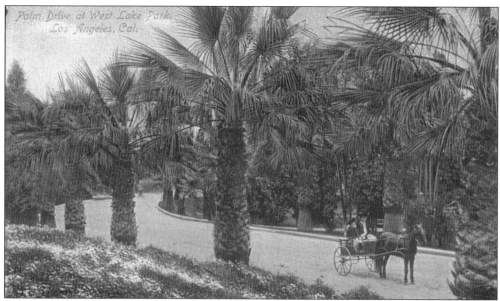

PALM DRIVE AT WESTLAKE PARK. A woman and her child take a ride in a one-horse chaise about 1905 in Westlake Park. The lush palm trees and the flowery bank provide tropical surroundings that have always appealed to visitors. (Published by Newman Post Card Co., Los Angeles.)

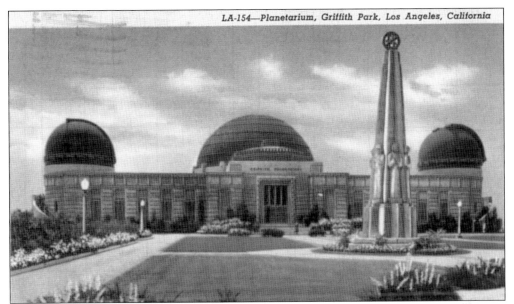

PLANETARIUM, GRIFFITH PARK. The 4,000-acre Griffith Park is one of the largest urban green spaces in America. It is named for Colonel G.J. Griffith, who bought the land in 1882 and gave it to the city in 1890; the park opened in 1912. Located northeast of Hollywood in the foothills of the Santa Monica Mountains, it is the nation's largest municipal park. Aside from stunning views, it offers golf, tennis, pony rides, a zoo, picnic grounds, and an observatory and planetarium. The latter houses the Foucault pendulum. The planetarium theatre recreates eclipses, northern lights, and cycles of the stars through use of the huge Zeiss projector. (Published by Western Publishing & Novelty Co., Los Angeles.)

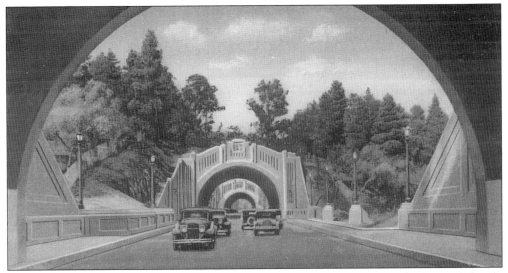

BOULEVARD THROUGH ELYSIAN PARK. Located just north of downtown, Elysian Park fronts the Pasadena Freeway as it follows the Arroyo Seco to Pasadena. This scene is evidence of the advanced highway development of the 1930s and the heavy traffic that was becoming a problem. Dodger Stadium is out of the picture to the left. (Published by Western Publishing & Novelty Co., Los Angeles.)

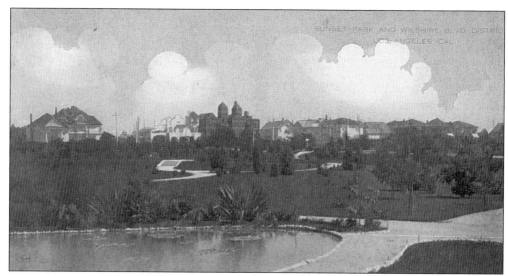

Sunset Park and Wilshire Boulevard District. Looking over the end of a small lake, we see a section of Los Angeles devoted to fine homes, apartments, and hotels. Wilshire Boulevard is one of the most famous streets in the city, proceeding west from downtown all the way to Santa Monica and the ocean. All of Hollywood lies in between. This card was mailed in 1909. (Published by Benham Indian Trading Co., Los Angeles.)

Exposition Park and the University of Southern California. Exposition Park is the location of the Memorial Coliseum, several important museums, and a sunken rose garden with more than 15,000 rose bushes representing 190 varieties. Begun in 1872 as a casual open-air market, it was deeded as an agricultural park for farmers to exhibit their products. Fairs, carnivals, and races have been frequent events here through the years. Visible in the center of this picture is Mudd Memorial Hall on the university campus. Modeled after a Medieval monastery, its bell tower is 146-feet high. It houses the philosophy faculty and the Hoose philosophy library of 60,000 volumes. (Published by H.S. Crocker Co., Los Angeles.)

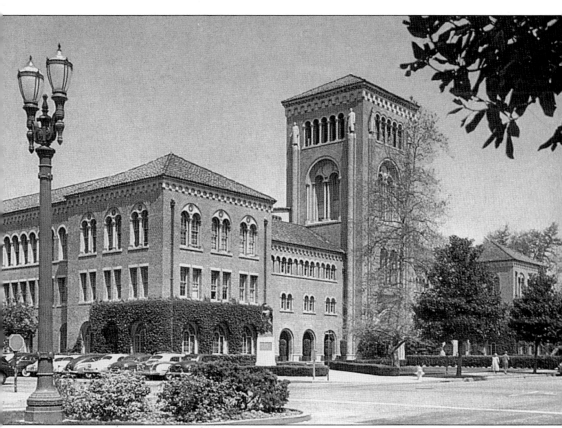

UNIVERSITY OF SOUTHERN CALIFORNIA ADMINISTRATION BUILDING. Across the street from Exposition Park, the University of Southern California covers 152 acres and is attended by almost 30,000 students. Founded in 1880, it is the oldest co-ed, and largest non-sectarian university in the western United States. The Bovard Administration Building seen here was named for USC's fourth president, George Bovard. Near the top of the tower one sees eight sculpted figures, including John Wesley, Abraham Lincoln, Theodore Roosevelt, Cicero, and Plato. The Italian Romanesque structure houses the 1,600-seat Norris Auditorium. (Published by Kolor Sales Co., Glendale.)

THE TROJAN STATUE. Outside the main entrance of Bovard Administration Building stands "Tommy Trojan," the 8-foot bronze statue of a Trojan warrior symbolizing the university and its motto, "Faithful, Scholarly, Skillful, Courageous, Ambitious." Housed in the university's 191 buildings are outstanding professional schools of architecture, law, medicine, dentistry, social work, education, engineering, and performing arts. The 152-acre campus is bounded by Jefferson and Exposition Boulevards, Figueroa Street, and Vermont Avenue. (Published by Longshaw Card Co., Los Angeles.)

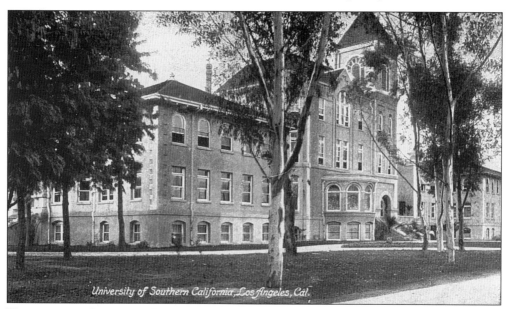

UNIVERSITY OF SOUTHERN CALIFORNIA "OLD COLLEGE." Built in the 1890s, "Old College" consisted of the central part of this building minus the rounded windows. The first permanent building at USC, it was erected at University Place, just south of Jefferson and west of Figueroa. (Published by M. Rieder, Los Angeles.)

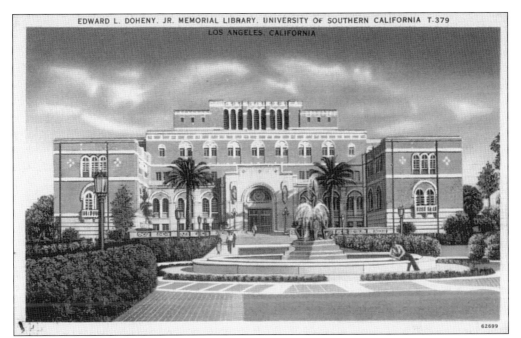

EDWARD L. DOHENY JR. MEMORIAL LIBRARY. A majestic building with Italian Romanesque styling, the Doheny Memorial Library at USC has also some Moorish and Egyptian influences. Built in 1932, it houses the university's principal reference collection. It was built in memory of Edward L. Doheny Jr., a trustee of the university who discovered oil near Second Street and Glendale Avenue and by 1905 had made his fortune, as did others. The building has a monumental marble staircase, ornate woodwork, and stained glass windows. (Published by Tichnor Art Co., Los Angeles.)

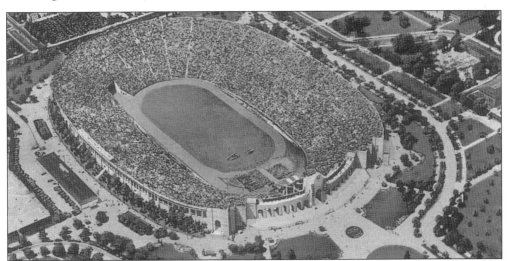

OLYMPIC STADIUM. The Los Angeles Memorial Coliseum is located in Exposition Park at 3939 Figueroa Street. Built in 1923, it has been host to the 1932 and the 1984 Olympic Games, and has been the site of many professional and USC football games. In 1960 John F. Kennedy made his acceptance speech here as candidate at the Democratic National Convention. (Published by Western Publishing & Novelty Co., Los Angeles.)

53

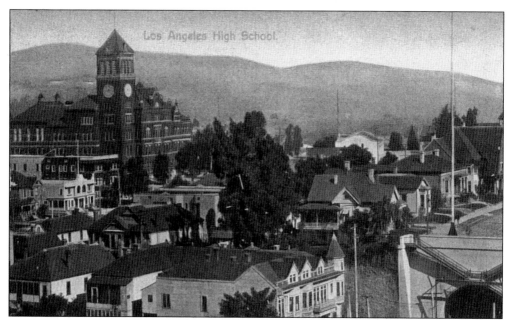

LOS ANGELES HIGH SCHOOL. A view of old Los Angeles is seen here, with the school dominating at left. This card was not mailed and so was not dated, but evidence indicates that it was printed between 1907 and 1920. The old high school was located at Castleton and Rock, in the North Hill-Fort Moore area. (Published by Newman Post Card Co., Los Angeles.)

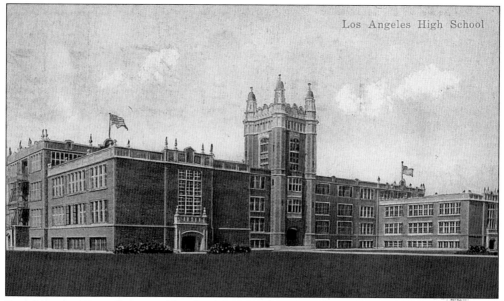

LOS ANGELES HIGH SCHOOL. This building replaced the old high school in 1917. The postcard was mailed in 1921, with the following message: "Came ashore this morning to have my teeth fixed, so thought I would drop in to see if I had any letters. Yours was waiting for me. Going down to Long Beach for a dip this afternoon. Want to come along?" (Published by Van Ornum Colorprint Co., Los Angeles.)

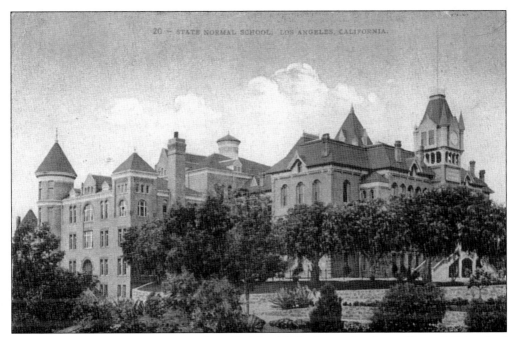

STATE NORMAL SCHOOL. A postcard mailed in 1910 shows the State Normal School of enormous size, though it grew much larger in succeeding decades to become the southern branch of the University of California. The school was then located at Fifth and Hope Streets, moving in 1914 somewhat farther west. It provided certification for future high school and elementary teachers. (Published by Edw. H. Mitchell, San Francisco.)

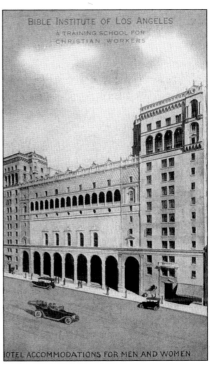

BIBLE INSTITUTE OF LOS ANGELES. Also home of the non-denominational Church of the Open Door, the Bible Institute of Los Angeles was located on the east side of Hope Street above Sixth, just south of the grounds of the Los Angeles Public Library. It long served as the scene of many conventions and religious events. It was torn down in the 1990s. (No publishing information given.)

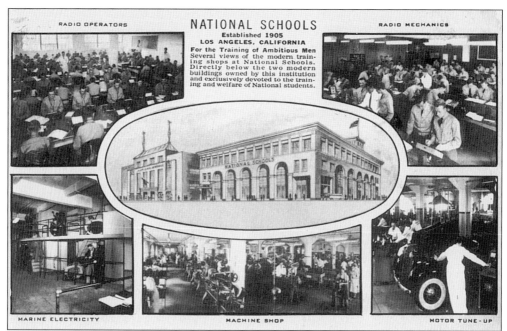

NATIONAL SCHOOLS. An advertising card for a correspondence school, this postcard shows much pertinent information on the front side. The back further informs us that National Schools "has trained thousands of men for success in the major modern trades" and that it offers "comprehensive authoritative instruction by correspondence." The sender of the card queries, "Shall you go to Florida this winter?" The card was sent in October 1942. (No publishing information given.)

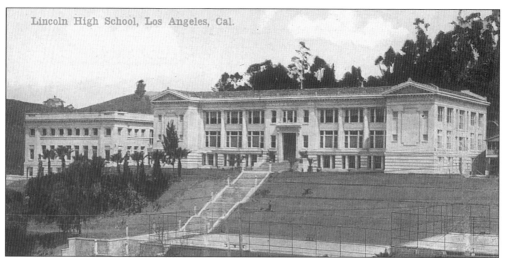

LINCOLN HIGH SCHOOL. Abraham Lincoln High School has served the Lincoln Heights section of Los Angeles for many years. It started as the Avenue 21 Intermediate School in 1911 and became Lincoln High School in 1918. The school officially became Abraham Lincoln High School in 1930. Looking closely at the layout of the property, one has to think students with physical disabilities were intimidated by the seven tiers of front steps. (Published by Van Ornum Colorprint Co., Los Angeles.)

Four
CHURCHES AND
RESIDENCES

LOS ANGELES MISSION. Also known as Our Lady, Queen of the Angels, Los Angeles Mission is the city's oldest church, standing on Main Street facing the Old Plaza. It was begun in 1784 and rebuilt in 1822, with the plain exterior typical of what became California mission style. (Published by Pacific Novelty Co., San Francisco.)

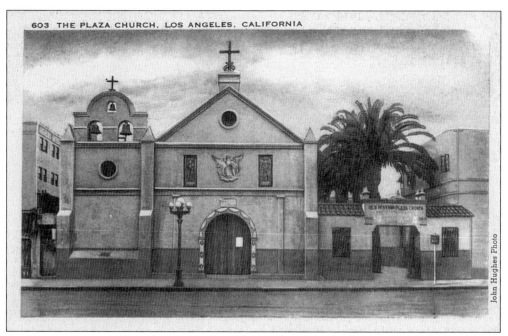

John Hughes Photo

THE PLAZA CHURCH. A later picture of Los Angeles Mission shows an additional building at right, as well as a decorative arch around the doorway. Above the door is a plaque and a mosaic of the Annunciation crafted by Isobel Piczek. The two windows in front are now made of stained glass. The building is still used as a parish church and contains a rich collection of paintings and statuary. (Published by Longshaw Card Co., Los Angeles.)

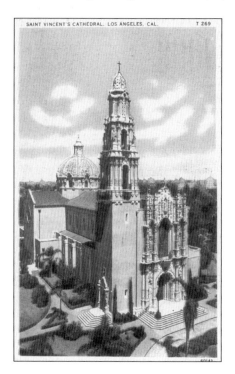

SAINT VINCENT'S CATHEDRAL. LOS ANGELES, CAL. T 269

SAINT VINCENT'S CATHEDRAL. On Figueroa Street at West Adams Boulevard, Saint Vincent's Cathedral is just around the corner from the Chester Place residence of the late Edward L. Dohenys, benefactors of this magnificent Roman Catholic church. One of the most outstanding architectural beauties of the city, St. Vincent's is unique in the quality of its ornament and high Gothic Style. (Published by Tichnor Art Co., Los Angeles.)

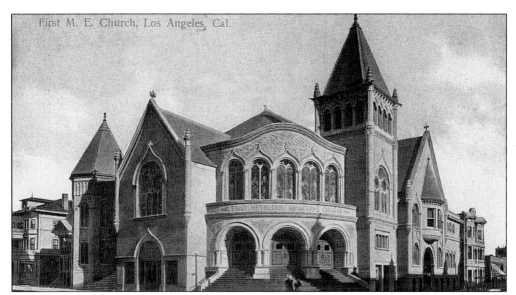

FIRST METHODIST EPISCOPAL CHURCH. A beautiful Gothic structure located on Hill Street, at the corner of Sixth opposite Central Park, this Methodist Episcopal church was photographed prior to 1911, when the postcard was sent. The card was posted to the Korean School in Honolulu and spoke of the sender's enrollment in the theological courses at "S.C. University." (Published by George O. Restall, Los Angeles.)

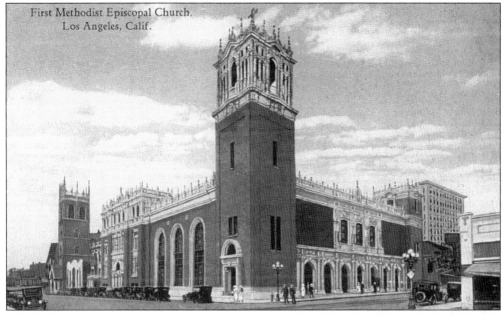

FIRST METHODIST EPISCOPAL CHURCH. Another impressive home for the First Methodist Episcopal Church is shown here some years later, on the southwest corner of Hope and Eighth. The automobiles at the curb help to date the scene to the 1920s. The delicacy of the ornamentation on the roof edgings is unusual, but the arches and stained glass windows are fine examples of the Gothic style. (Published by Western Publishing & Novelty Co., Los Angeles.).

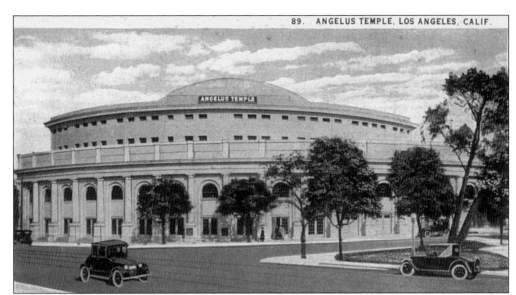

ANGELUS TEMPLE. In the 1920s and 1930s, Aimee Semple McPherson preached her Foursquare Gospel in this circular structure at 1100 Glendale Boulevard in Echo Park. The large domed building was similar in design to the Mormon Tabernacle in Salt Lake City. "Sister Aimee" had her own radio station and publishing house, and thus anticipated many modern day media preachers, very few of whom have even approached her charisma and public relations success. She was later involved in a scandal which alleged immoral conduct, but her fame has never diminished. (Published by Western Publishing & Novelty Co., Los Angeles.)

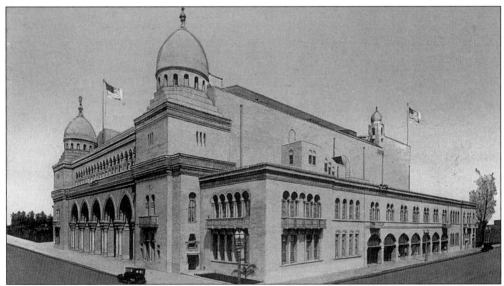

AL MALAIKAH TEMPLE, SHRINE AUDITORIUM. This huge building of Moorish design is located at Jefferson and Royal Streets. In 1936 the sender of this card said, "From 9:30 to 10:30 Mrs. Rogers led the choir at Xmas Eve service. I sat next to Nell...A mass of flowers on the stage a large number of ladies in evening dress. Mr. Ross and I visited the reading room." (Published by Western Publishing & Novelty Co., Los Angeles.)

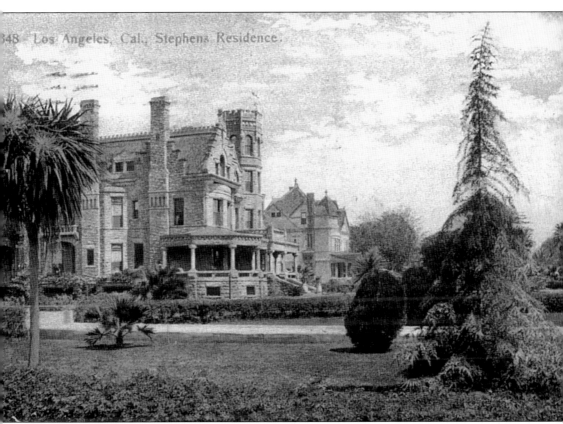

STEPHENS RESIDENCE. At the turn of the century many wealthy residents of Los Angeles built Victorian homes looking either like castles or Queen Anne "gingerbread" houses with turrets and fancy wood carvings. This formidable castle is evidence of the wealth and importance of its owner. The card was mailed in 1908. (Published by Paul C. Koeber Co., New York City.)

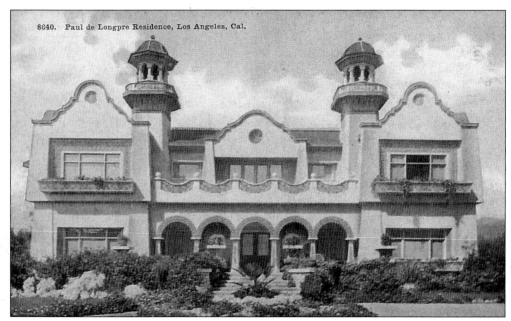

8640. Paul de Longpre Residence, Los Angeles, Cal.

PAUL DE LONGPRE RESIDENCE. Famous flower artist Paul de Longpre built this Moorish residence in Hollywood. It became one of Hollywood's first tourist attractions. When this home was built, it was in the middle of a hayfield, a location the locals found most interesting. Other early residents built houses of exotic design, including the Oriental. (No publishing information given.)

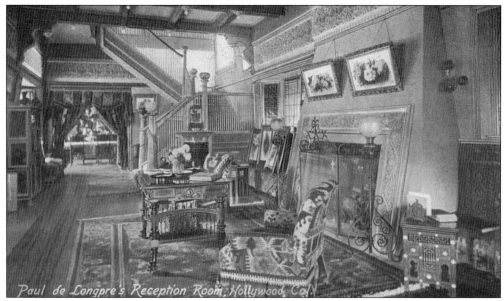

PAUL DE LONGPRE'S RECEPTION ROOM. Victorian style rooms can be identified by their heavy decoration, typified in this room. From the velvet upholstery with is audacious pattern, the gilt side table, the heavily carved and ornamented center table, to the velvet drapes at left distance, we see Victorian elements. Longpre's flower drawings have an important place above the fireplace and in stacks to the left. (Published by M. Rieder, Los Angeles.)

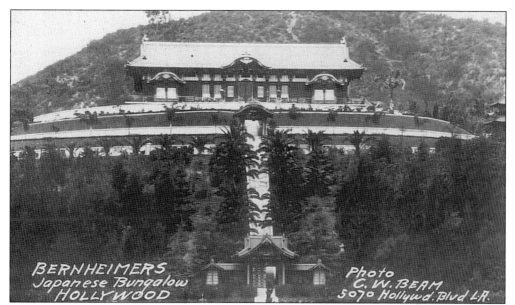

BERNHEIMER'S JAPANESE BUNGALOW. One of the major cultural influences in Los Angeles is that of the Japanese, represented today by approximately 200,000 inhabitants of Japanese heritage. The Bernheimer's Japanese bungalow was an early example of the new style of house—long and low, quite different from the multiple-storied and turreted Victorian concepts. The uncovered veranda extends the whole length of the front of the house. (A real-photo postcard; no publisher given.)

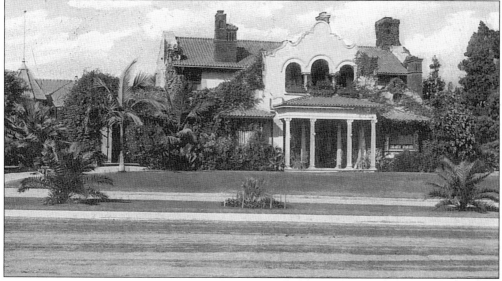

RESIDENCE OF HARRISON GRAY OTIS. One of the most important wealthy men of Los Angeles in the early part of the 20th century was Harrison Gray Otis, proprietor of the *Los Angeles Times*. On October 1, 1910, the *Times* Building was bombed by members of the typographical union, resulting in 20 deaths and a great scandal. Otis was in the midst of the controversy, some saying he was in collusion with the perpetrators. This card was sent in 1909. (Published by Paul C. Koeber Co, New York City.)

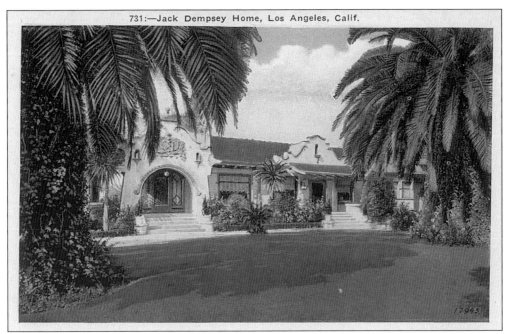

JACK DEMPSEY HOME. The elaborate home of retired boxer Jack Dempsey reflects the wealth he achieved from his career. Dempsey was world heavyweight champion from 1919, when he knocked out Jess Willard, to 1926, when he was defeated by Gene Tunney. Dempsey was the first fighter in boxing history to sell a million dollars worth of tickets for one bout. (Published by M. Kashower, Los Angeles.)

RESIDENCE OF E.P. BRYAN, WESTMORELAND PLACE. Located in one of the most fashionable sections of Los Angles in the first decades of the 20th century, E.P. Bryan's residence reflects his wealth and ostentatious eclecticism. It is a mixture of styles, from Victorian to Japanese—a bit of everything. (No publishing information given.)

64

Five
SCENES AND SIGHTS

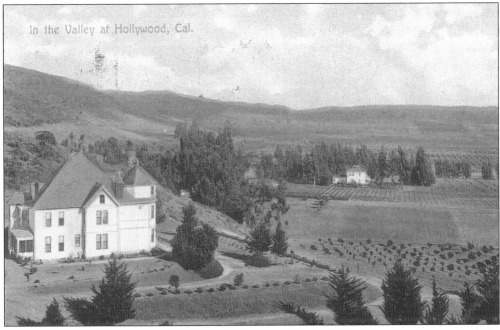

IN THE VALLEY AT HOLLYWOOD. Hollywood is not a suburb of Los Angeles; it is part of the city, lying just west of downtown. This early card, sent in 1908, shows a great expanse of undeveloped land, soon to be filled with homes, shops, and movie studios. The sender communicates a message common to many postcards: "Papa is bedfast again. Will write you later about his illness." (Published by Newman Post Card. Co., Los Angeles.)

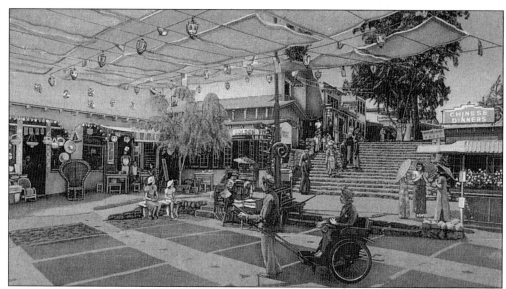

PLAZA IN CHINA CITY. Los Angeles' Chinatown used to be located on the present site of the Union Station; it was moved in the 1930s to accommodate the building of the station. Now it flourishes between the 100 and 1000 blocks of North Broadway. It is one of Los Angeles' major ethnic communities, containing approximately 10,000 inhabitants. The Chinese first came to Los Angeles during the Gold Rush to work in the mines and to build the railroads. Confronted with prejudice, they formed a tightly-knit community about 1870. They continue to build their highly ornamental buildings and to pursue their celebrations and parades. (Published by Western Publishing & Novelty Co., Los Angeles.)

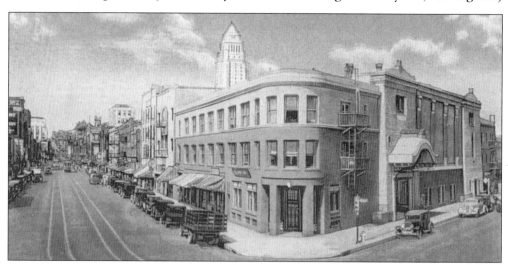

"LITTLE TOKYO," EAST FIRST STREET. Los Angeles' large Japanese community lies between First, Third, Los Angeles, and Alameda Streets. First settled about 1885, it is now a tourist attraction with thousands of visitors annually. In the 1920s it began to flourish; however, it was devastated by the forced evacuation of the Japanese from the Pacific Coast during World War II. Since returning to their homes and businesses, they have emerged commercially and culturally. This postcard dates from the early 1930s. (Published by Tichnor Art Co., Los Angeles.)

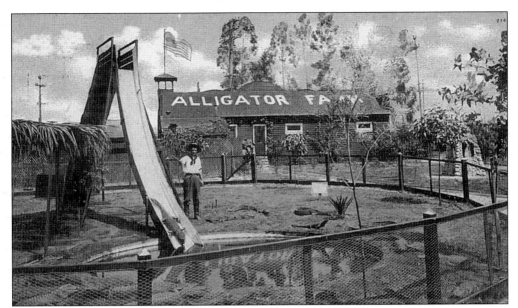

TRAINED ALLIGATORS SHOOTING THE CHUTES. An unlikely choice for tourist education about historical Los Angeles, the alligators nevertheless have provided amusement and diversity for visitors for many decades. This card was sent in 1912 with the message: "I didn't get a card from you today. You owe me one." It was mailed to a correspondent in the Title Insurance Building in Los Angeles. (Published by the Benham Co., Los Angeles.)

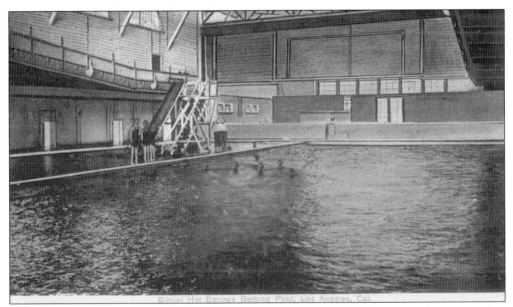

BIMINI HOT SPRINGS, BATHING POOL. Another diversion for tourists is shown on this postcard mailed in 1910. The Bimini Hot Springs evidently had an extremely large pool for the health and comfort of visitors, and was contained in a "bath house and Inn, quite pretty, built in mission style," according to the correspondent. She further says, "How would you like to go swimming in this pool? We pass these springs every time we go to town." (Published by Los Angeles News Co., Los Angeles.)

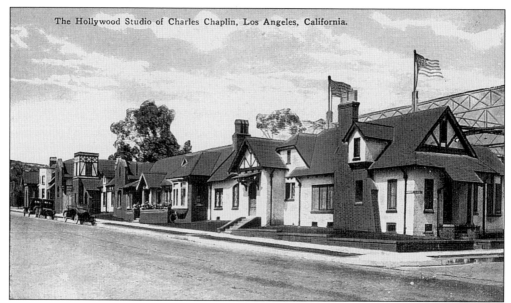

The Hollywood Studio of Charles Chaplin, Los Angeles, California.

THE HOLLYWOOD STUDIO OF CHARLES CHAPLIN. Along with Mary Pickford and D.W. Griffith, Charles Chaplin was one of the founding pioneers of the movie industry. This postcard shows a modest, undistinguished studio building, which does not reflect the enormous fame and wealth that came later. The year is between 1910 and 1915. (Published by California Greeting and Post Card Co., Los Angeles.)

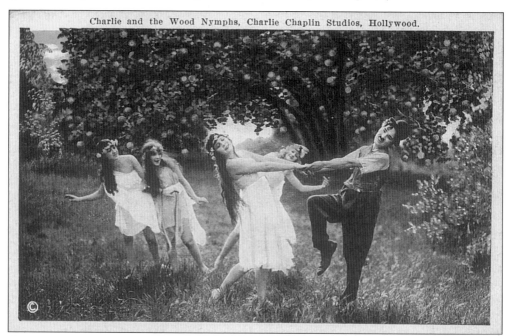

Charlie and the Wood Nymphs, Charlie Chaplin Studios, Hollywood.

CHARLIE AND THE WOOD NYMPHS. In his familiar guise as the "Little Tramp," Charlie Chaplin starred in many early movies made in his own studios. The scene pictured here is from *Sunnyside*, one of many comedies and fantasies he produced around 1915. (Published by California Post Card Co., Los Angeles.)

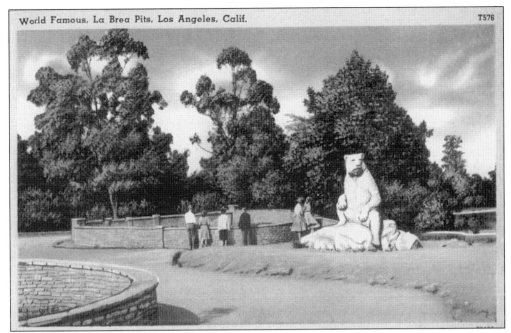

WORLD FAMOUS LA BREA PITS. Located at 5801 Wilshire Boulevard between La Brea and Fairfax Avenues, the La Brea Tar Pits are vast holes in Hancock Park oozing with tar ("brea" in Spanish). Early natives and settlers used the tar to seal boats and roofs. In 1906 geologists discovered fossils of over 200 varieties of mammals, plants, reptiles, birds, and insects from the Pleistocene Era buried here. (Published by Tichnor Art Co., Log Angeles.)

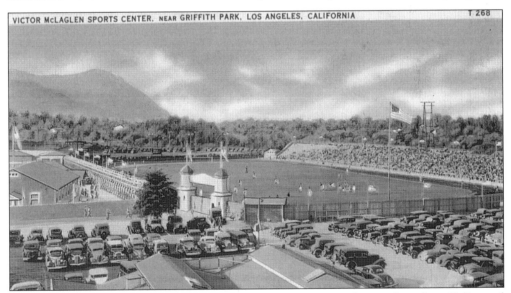

VICTOR MCLAGLEN SPORTS CENTER, NEAR GRIFFITH PARK. Located at Los Feliz and Riverside Drive, the McLaglen Field and Sports Center are named for the great movie star of the 1920s and 1930s whose appearance in *The Lost Patrol* and *The Informer* were especially memorable. This card from 1938 shows a well-attended event. (Published by Tichnor Art Co., Los Angeles.)

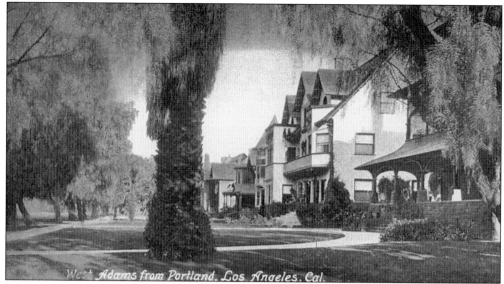

WEST ADAMS FROM PORTLAND. A quiet street lined with mature palm trees just off Figueroa Street illustrates an upper middle-class neighborhood. These were three-storied houses with servants' quarters; they had balconies or verandas, popular in the early 1900s. The house on the extreme right was the residence for many years of the Newmark family, wholesale hardware merchants. Later it became the Phi Gamma Delta Fraternity House for nearby University of Southern California. (Published by M. Rieder, Los Angeles.)

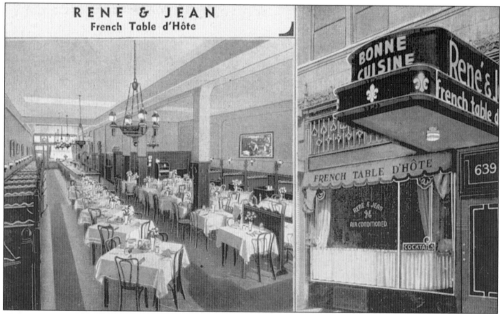

RENE AND JEAN, FRENCH TABLE D'HOTE. An advertising card from the 1940s presents Rene and Jean's French Table d'Hote, located at 639 S. Olive Street. It is a modest establishment with a small storefront window and small booths and tables within. Most restaurants nowadays produce postcards advertising themselves, many to be given away on the premises. (Published by E.C. Kropp, Milwaukee.)

PASADENA

One

OVERVIEW AND STREETS

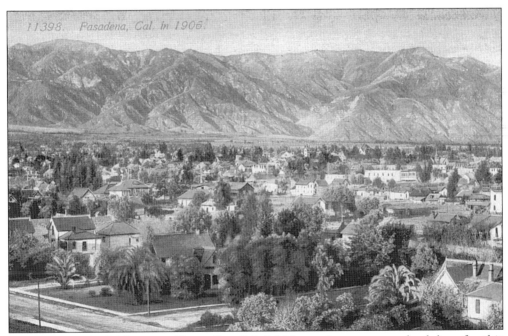

PASADENA IN 1906. The magnificent San Gabriel Mountains serve as a backdrop for this early view of the residential section of Pasadena. The viewer will notice the dirt streets and primarily frame construction of these houses situated north of Colorado Street, east of the business district. (Published by Acmegraph Co., Chicago.)

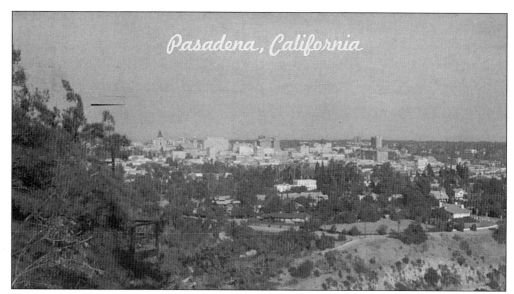

PASADENA. When the Santa Fe Railroad was completed in 1887, many wealthy people from the east settled in Pasadena. It became the richest city in America, and its affluent inhabitants have endeavored to keep it that way. They have provided a splendid cultural legacy especially in gardens and art collections. This view looks across the arroyo at the city from the Linda Vista area, just north of the Colorado Street Bridge. (Published by Western Publishing & Novelty Co., Los Angeles.)

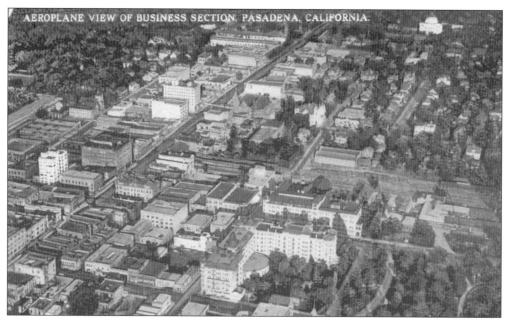

AEROPLANE VIEW OF BUSINESS SECTION, PASADENA. Downtown Pasadena is presented here looking east. The Green Hotel is impressive at front center, opposite the First Church of Christ, Scientist, at upper right. Colorado Boulevard, which runs from left front to upper center, is the principal street in Pasadena and is currently the route of the Tournament of Roses parade. (Published by Western Publishing & Novelty Co., Los Angeles.)

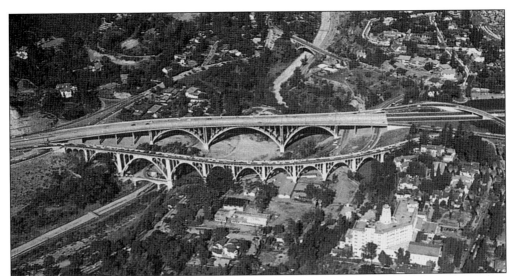

COLORADO STREET BRIDGE, PASADENA. Believed to be the largest span on a curve in the United States, the Colorado Street Bridge was built in 1913 to cross the Arroyo Seco. These graceful concrete arches support a span 160-feet high, and have tempted more than 100 people to jump to their deaths, thus giving it the name of "Suicide Bridge." The bridge was closed in 1987 to undergo a $27.4 million restoration, including a new spiked suicide-prevention fence. (Published by Colourpicture, Boston.)

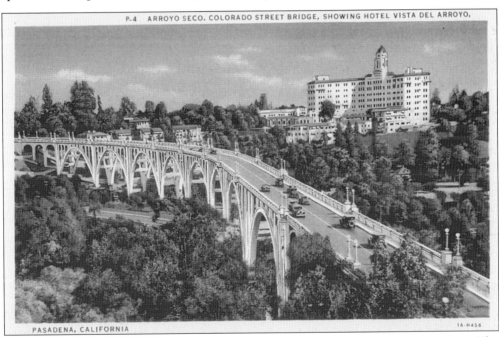

ARROYO SECO, COLORADO STREET BRIDGE, SHOWING HOTEL VISTA DEL ARROYO. The unusual scene here includes the Colorado Street Bridge over the Arroyo Seco looking east toward downtown Pasadena. The building at right is the Hotel Vista del Arroyo. Coming westward, Colorado Street proceeds to Eagle Rock, Glendale, and finally ends at Griffith Park. (Published by Western Publishing & Novelty Co., Los Angeles.)

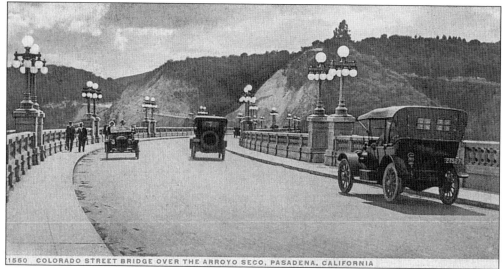

1550 COLORADO STREET BRIDGE OVER THE ARROYO SECO, PASADENA, CALIFORNIA

Colorado Street Bridge Over the Arroyo Seco. Looking west on the Colorado Street Bridge, we see the famous curve and three early automobiles. The San Rafael Hills ahead seem mostly empty of housing at this time. The bridge was well engineered; there were concrete surfaces, sidewalks for pedestrians, and elegant lighting fixtures. (Published by the Detroit Publishing Co., Detroit.)

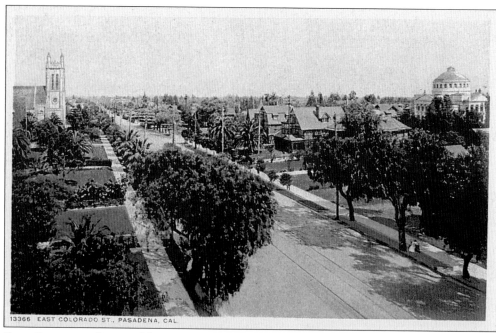

13366 EAST COLORADO ST., PASADENA, CAL.

East Colorado Street. The most important street in Pasadena, Colorado Street here looks east from downtown. It is a quiet residential area, judging from the neat row of houses at right. The well-kept lawns at left surely belong to other neat houses. At left we see the Pasadena Presbyterian Church, and at far right we see the First Church of Christ, Scientist. Streetcar tracks indicate that convenient transportation is available. (Published by Detroit Publishing Co., Detroit.)

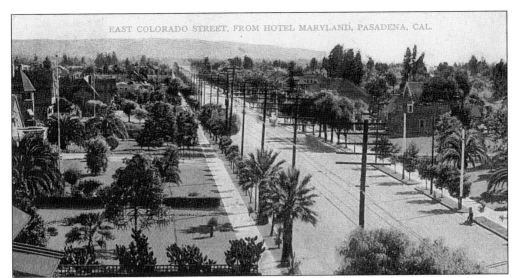

EAST COLORADO STREET, FROM HOTEL MARYLAND. In 1909 when this postcard was mailed, East Colorado Street was primarily residential; however, to look west from this vantage point means that the viewer is practically downtown. Not a vehicle is in sight, but the streetcar tracks indicate the current transportation. There is a great clutter of telephone poles among the palm trees. (Published by L.R. Severn, Los Angeles.)

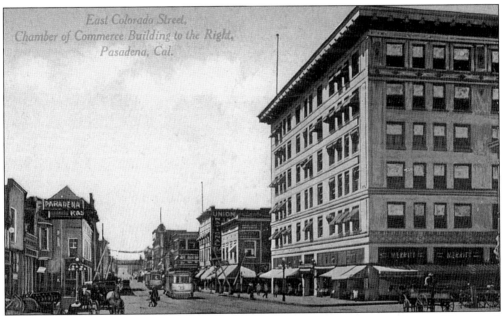

EAST COLORADO STREET, CHAMBER OF COMMERCE BUILDING TO THE RIGHT. The usual activities at Colorado Street and Marengo Avenue in 1910 are pictured here. Horse-drawn conveyances still prevail; there are trolleys, modest in size. Even the Chamber of Commerce Building has only six stories and the Union National Bank Building farther down the street is even smaller. T.W. Mather's dry good store occupied the corner building for many years and was there as early as 1920. (Published by Newman Post Card Co., Los Angeles.)

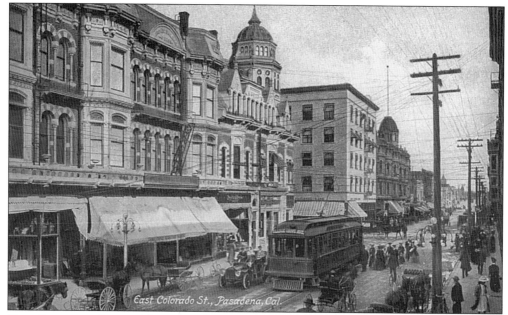

EAST COLORADO STREET. The Orange Grove Avenue streetcar waits to take on passengers in this view at Fair Oaks Avenue and Colorado Street about 1910. The Arcade Building on the left was built in 1888; the Slavin Building on the next corner was built in 1909. The old lighting fixtures are still in place, but the automobile alongside the streetcar is a sign of things to come. (Published by M. Rieder, Los Angeles.)

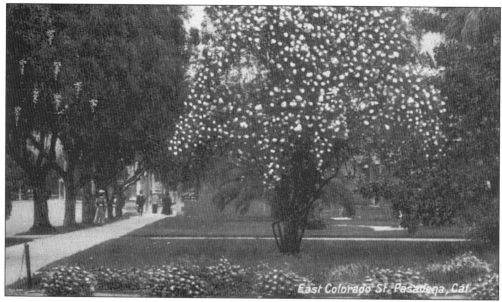

EAST COLORADO STREET. Flowering trees such as this are found in abundance in Pasadena, adding to the city's unique beauty. The scene on Colorado Street also gives glimpses of a building beyond the flowering tree which may be a home or a hotel. The ladies' dresses indicate the time and the postmark validates it. The card was sent June 27, 1910. (Published by Newman Post Card Co., Los Angeles.)

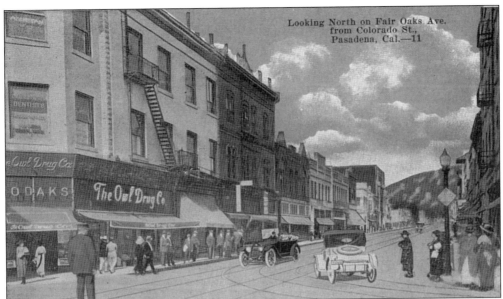

LOOKING NORTH ON FAIR OAKS AVENUE. A policeman directs traffic in this early view looking north on Fair Oaks. The Owl Drug Company was a major drug chain at this time, about 1920. This card was printed after World War I; we observe three different lengths of women's dresses. Note the advertisement for Kodaks above the Owl Drug Co. entrance. (No publishing information given.)

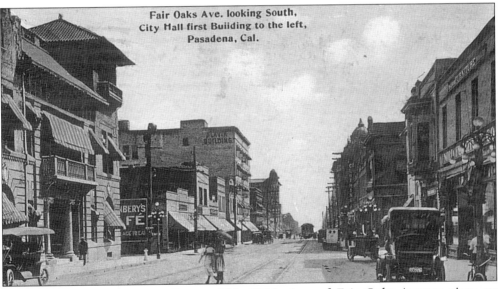

Fair Oaks Ave. looking South,
City Hall first Building to the left,
Pasadena, Cal.

FAIR OAKS AVENUE LOOKING SOUTH. This 1913 view of Fair Oaks Avenue gives an interesting index to changing times. The old city hall at left sits at the Union Street corner, showing its age. The girls in the street show that fashions decree shorter skirts; the transport now includes several styles of autos, a truck, a trolley, and the still-present horse-drawn conveyances. The Slavin Building at center sits on the Colorado Street corner, and the Green Hotel tower is visible at center. (Published by Western Publishing & Novelty Co., Los Angeles.)

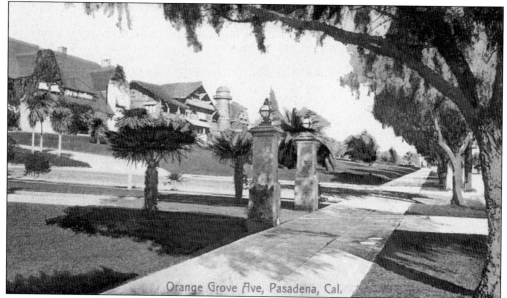

ORANGE GROVE AVENUE. South Orange Grove Avenue, shown here looking northwest, was literally "Millionaire's Row" early in the century. Many of these homes have been replaced by condominiums, but some remain. The Tournament of Roses parade begins here each year; it is the home of the Valley Hunt Club. The Busch mansion is at left; the tower of "The Blossoms" is at center distance. (Published by M. Rieder, Los Angeles.)

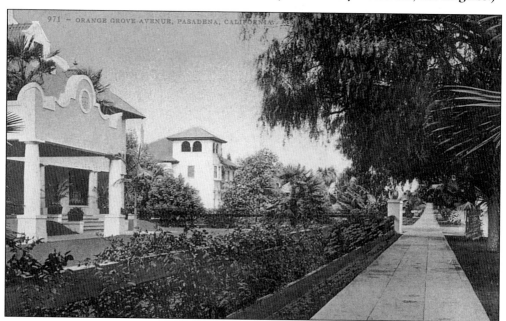

ORANGE GROVE AVENUE. The houses on "Millionaire's Row" continue to illustrate the variety and richness of design accumulated on this major street. The Wrigley House on Orange Grove (not pictured) is one of the few remaining mansions here; it is the location the Tournament of Roses Association offices. The Valley Hunt Club also has facilities on Orange Grove. (Published by Edward H. Mitchell, San Francisco.)

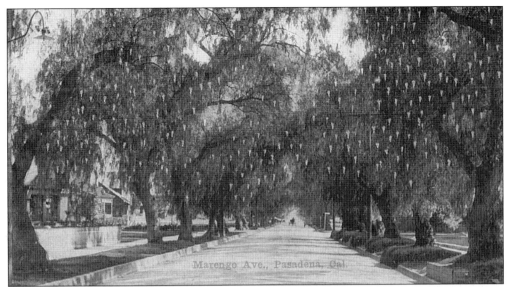

MARENGO AVENUE. The unbelievably lush foliage of the pepper trees on Marengo Avenue and elsewhere in Pasadena attracts much notice. Marengo is a major north-south street that runs the length of Pasadena. The tops of the trees in this residential section actually meet over the street, giving the illusion to a driver below of going through a tunnel. (Published by Newman Post Card Co., San Francisco.)

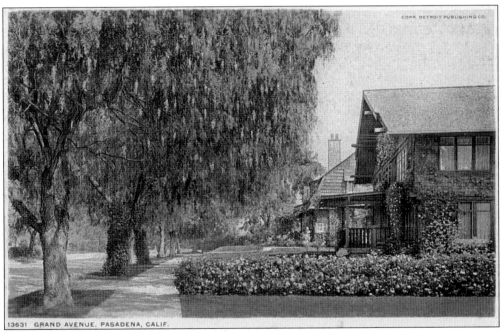

GRAND AVENUE. One of the earliest fine residential streets in Pasadena was Grand Avenue, one block west of South Orange Grove. This view looks south below the Vista del Arroyo Hotel. These beautiful old homes were also favored with pepper trees, which unfortunately caused so much fall-out on the street that most of them had to be removed. (Published by Detroit Publishing Co., Detroit.)

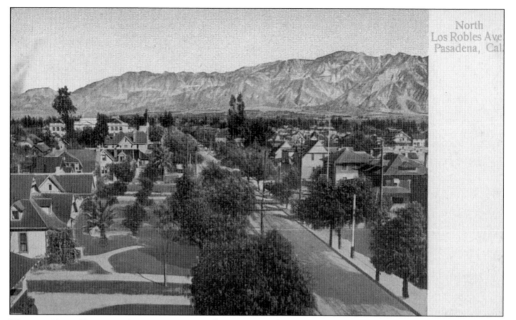

NORTH LOS ROBLES AVENUE. Upon leaving Colorado Street and going north on Los Robles Avenue, one would see an unfolding scene of well kept rows of modest homes in a very different setting from the mansions of Orange Grove Avenue. Pasadena High School can be seen in the left distance. (Published by M. Rieder, Los Angeles.)

ST. FRANCIS COURT. Flanked by two enormous pepper trees, the little community of St. Francis Court stood at 777 E. Colorado Street from 1909 until 1925. It was removed to make way for the extension of Oak Knoll north to Union Street. (Published by Van Ornum Colorprint, Los Angeles.)

Two
RESIDENCES AND
COMMERCIAL BUILDINGS

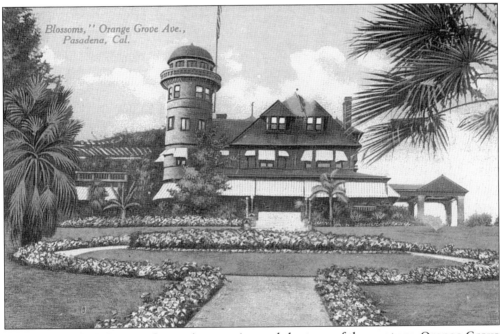

"THE BLOSSOMS," ORANGE GROVE AVENUE. Around the turn of the century, Orange Grove Avenue became the gathering place of millionaires, whose elegant and expensive mansions became more numerous every year. The street was a fantasy land of beautiful flowers and palatial homes. It was known as "the picture street of Pasadena" and "the Fifth Avenue of Pasadena." "The Blossoms" is easily one of the most spectacular of these mansions; its tower gives it a special prominence, as does its circular flower arrangement in front. (Published by the O. Newman Co., Los Angeles.)

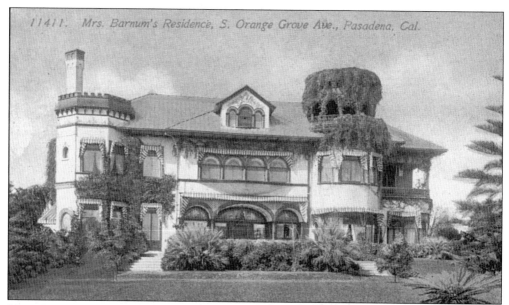

MRS. BARNUM'S RESIDENCE, ORANGE GROVE AVENUE. Built in 1895 for Henry C. Durand, millionaire Chicago grocer, this Gothic stone mansion evoked yet another style favorite to turn-of-the-century builders. Sold first to the Barnum family, the home later was purchased about 1915 by William Wrigley, the chewing gum mogul, and demolished to make room for Wrigley's pergola and rose garden. (Published by Acmegraph Co., Chicago.)

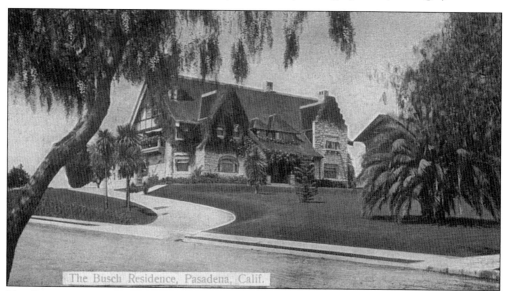

The Busch Residence, Pasadena, Calif.

THE BUSCH RESIDENCE. The home of Adolphus Busch, the St. Louis beer millionaire, was one of the elaborate dwellings on Orange Grove Avenue. These homes were big, solid, and cool-looking with brick and stone walls and terra cotta tile roofs. Downstairs windows were leaded, and upper windows usually had fanciful trimming. Large green lawns sloped to the street. The Busch residence also had a sunken garden in the back yard, an elaborate formation of terraces and formalized flower arrangements. (Published by George O. Restall, Los Angeles.)

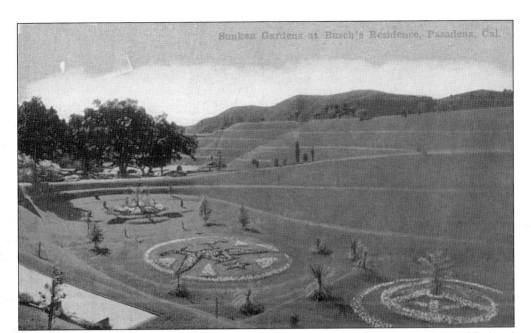

SUNKEN GARDENS AT BUSCH'S RESIDENCE. Busch's Sunken Gardens were situated behind the Busch estate on South Orange Grove Avenue and terraced down toward Arroyo Seco. Acres of closely cropped lawn interspersed with huge flower beds, some in patterns, made up the elaborate setting. The gardens became a huge tourist attraction. (Published by the O. Newman Co., Los Angeles.)

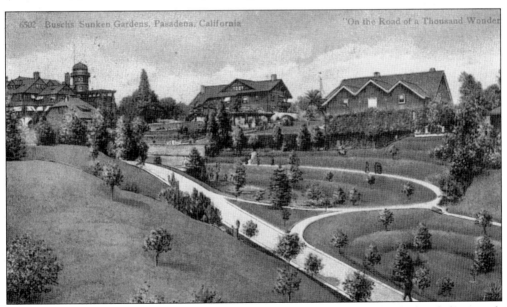

BUSCH'S SUNKEN GARDENS. The lavishly landscaped Sunken Gardens behind the Busch residence extended for some distance behind other mansions on Orange Grove Avenue, as seen here. The tower of "The Blossoms" can be seen at left distance. Busch died in 1913, and Mrs. Busch maintained the house until the 1940s, when it was sold and demolished. (Published by Cardinell-Vincent Co., San Francisco.)

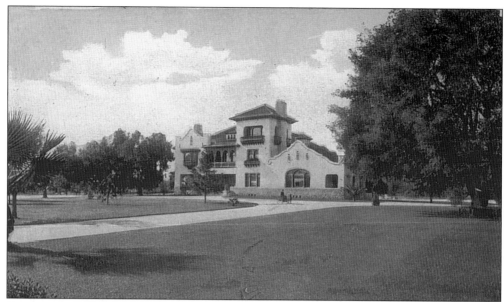

THE STUART RESIDENCE. An expensive home in the Spanish colonial style, this house was designed in 1897 for W.C. Stuart. This view is unusual because we see no elaborate gardens at the front; instead we see only the huge lawn sloping to the street. Perhaps the gardens were out back. (Published by Paul C. Koeber Co., New York.)

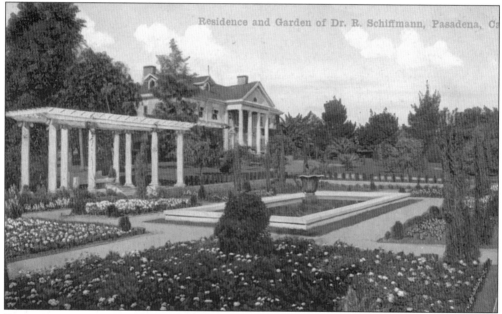

Residence and Garden of Dr. R. Schiffmann, Pasadena, Ca

RESIDENCE AND GARDEN OF DR. SCHIFFMANN. The imposing Greek styled residence and formal gardens of Dr. Rudolph Schiffmann were located at 505 S. Grand Avenue. The pergola was an addition much favored at this time. Located on the west side of Grand just off the east bank of the Arroyo, the house joined others of the West Side in making Pasadena "the richest city in America." (Published by Souvenir Publishing Co., San Francisco.)

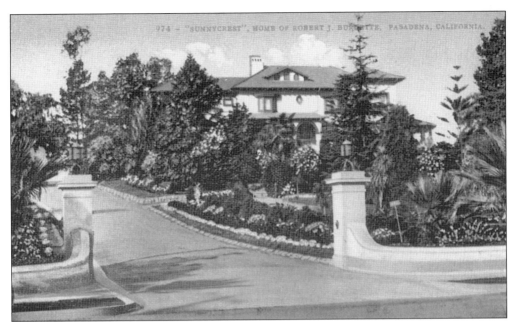

"Sunnycrest," Home of Robert J. Burdette. Another showplace of South Orange Grove was the home of Dr. Robert and Clara Burdette. Dr. Burdette—author, humorist, and longtime minister of Temple Baptist Church in downtown Los Angeles—married widow Clara Baker in 1899. With the marriage came Clara's wealth and the Orange Grove mansion, "Sunnycrest." Mrs. Burdette became a prominent clubwoman, founding the Women's Civic League in Pasadena, as well as being president of the National Federation of Women's Clubs. "Sunnycrest" was famous for its view of the arroyo and the mountains. (Published by Edw. H. Mitchell, San Francisco.)

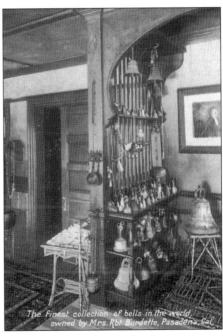

The Finest Collection of Bells in the World. Mrs. Robert Burdette, who lived in her famous mansion on Orange Grove Avenue, was an avid collector of bells, which reflected the symbolism relevant to the California mission culture. She was married three times; as she said, "once for love, once for money, and once for prestige."

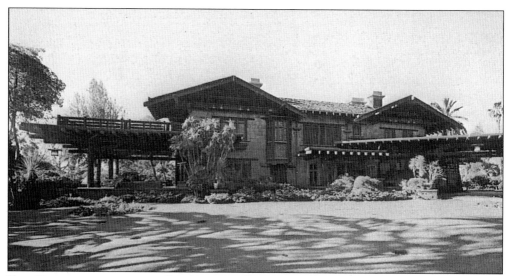

THE BLACKER-HILL HOUSE. The historic Blacker-Hill house by architects Charles and Henry Greene, was built about 1907. Located at 1177 Hillcrest Avenue, it is owned by Mr. and Mrs. Max Hill. Notable that its style reflects Japanese influences prevailing at the time, it has wide terraces and overhanging eaves, ideal for the California climate. The house heavily affected future building practices in Pasadena, and is an acknowledged masterpiece of California craftsman architecture. (Published by Columbia Wholesale Supply, North Hollywood.)

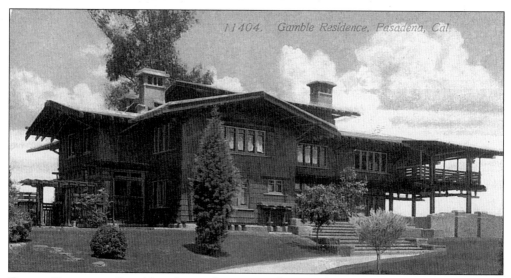

GAMBLE RESIDENCE. Considered now the outstanding model of its era, the Gamble House was built in 1908 of polished teak by Charles and Henry Greene for David Gamble of the Proctor and Gamble Company. The house epitomizes the Arts and Crafts Movement which stressed simplicity of design. Influenced by Japanese architecture, it utilizes open sleeping porches and cross ventilation, which provides natural air conditioning. It has a stained-glass front door, which is illuminated by the sun at certain times of day. The house, located at 4 Westmorland Place, is now maintained by the USC School of Architecture as a study center and retreat for visiting scholars. (Published by Acmegraph Co., Chicago.)

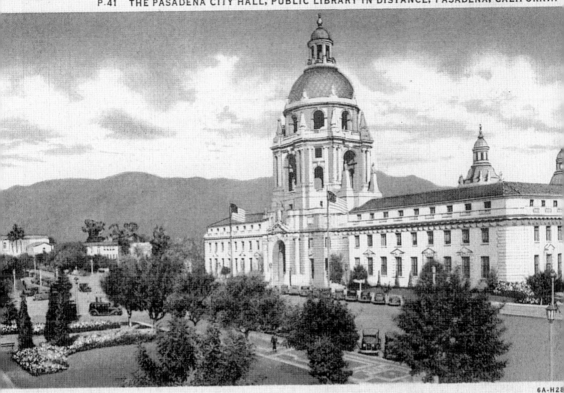

6A-H28

THE PASADENA CITY HALL. Designed in 1925 by John Bakewell Jr. and Arthur Brown, this handsome domed baroque building is located at 100 N. Garfield Avenue at Union Street. Nearby in the Civic Center complex are the police station, post office, library, and Civic Auditorium. Mt. Lowe and Mt. Wilson are in the distance. Ever-present flowers decorate the lawn, and 1930s vintage automobiles are at the curb. (Published by Western Publishing & Novelty Co., Los Angeles.)

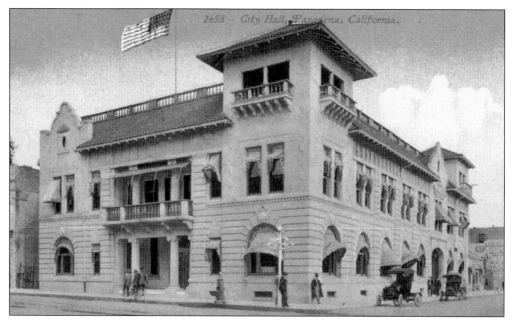

CITY HALL, PASADENA. Prior to the advent of the new city hall in 1925, this building served the city in that capacity. Smaller in size than the new structure, it was nevertheless attractively designed with Spanish colonial and Renaissance elements. The cars at the curb indicate the time to be about 1905. It was located on Fair Oaks Avenue at Union. (Published by Edw. H. Mitchell, San Francisco.)

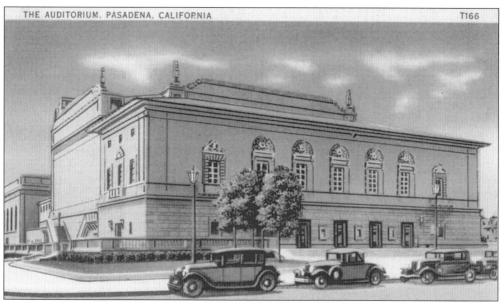

THE AUDITORIUM, PASADENA. The Civic Auditorium of Pasadena was built in 1932 at a cost of $1.25 million. It is the home of the Pasadena Symphony Orchestra and varied other music, dance, and theatre events. It can seat three-thousand people. It houses a 1920s Moeller theatre organ, the largest of its kind west of the Mississippi. (Published by Tichnor Art Co., Los Angeles.)

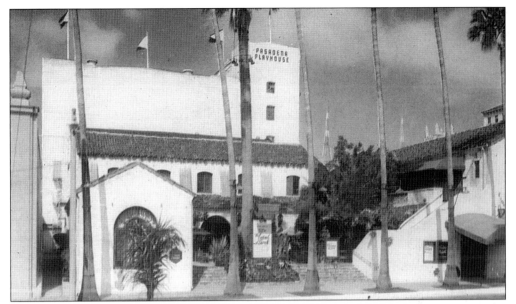

THE PASADENA COMMUNITY PLAYHOUSE. Organized in 1916 as a little theatre group, the Pasadena Community Playhouse now has a nationally recognized theatre school. This theatre, built in 1925, seats 850 patrons, and has been the scene of many important stage productions. It is located on El Molino just south of Colorado Boulevard. (Published by Longshaw Card Co., Los Angeles.)

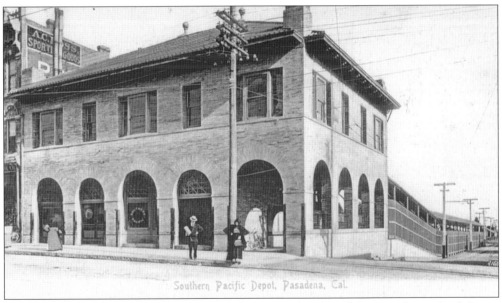

SOUTHERN PACIFIC DEPOT. The first intercontinental railroad line in the United States was completed in 1869, linking San Francisco to the Atlantic coast. In 1876 a route to Pasadena was established, and during the 1880s an enormous boom in rail travel took place. Southern Pacific (owned by the Huntingtons and three other investors) was first to arrive. This early postcard shows the Southern Pacific Depot at Pasadena at the turn of the century. (Published by M. Rieder, Los Angeles.)

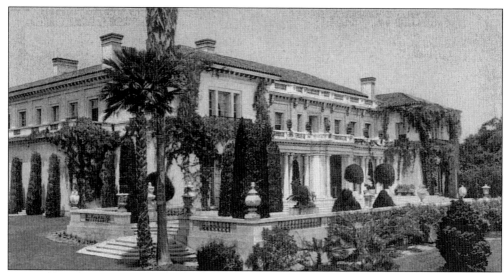

HENRY E. HUNTINGTON LIBRARY AND ART GALLERY. The Huntington mansion was built between 1909 and 1911 for Henry E. Huntington (1850–1927), who made his fortune building interurban electric trolleys. This mode of transportation revolutionized the growth of greater Los Angeles because it made possible easier access to suburbs in all directions. Located between Los Angeles and Pasadena,the community of San Marino is the site of the mansion which was put into a trust by the Huntingtons in 1919, creating a non-profit research institution. It has become one of the world's great libraries and art museums, featuring its collection of 18th-century British art. (Published in Switzerland by Atelier Graphique H. Vontobel, Feldmeilen.)

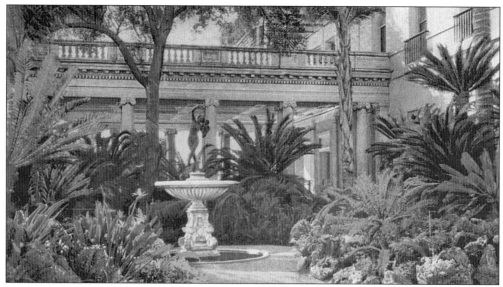

HENRY E. HUNTINGTON LIBRARY AND ART GALLERY—THE PATIO. A view of the patio at Huntington Library and Art Gallery includes lush growths of tropical flowers and bushes interspersed with classical statuary. A pergola with classical columns and much other ornamentation supplies eye-catching splendor seldom equaled elsewhere. (Published in Switzerland by Atelier Graphique H. Vontobel, Feldmeilen.)

HENRY E. HUNTINGTON (1850–1927).
Blessed with intelligence, business
sense, and inherited wealth, Henry E.
Huntington accomplished world-
changing enterprises. Participating in his
family investments in railroading, he
activated an electric interurban trolley
system in Los Angeles which made real
estate booms possible. When he had
achieved his wealth, he retired from
business affairs (about 1920) and began
to accumulate the finest private library
of his day, an almost unparalleled
storehouse of English and American
documents and books. Included are a
Gutenberg Bible, original editions of
Shakespeare and Dickens, and letters of
Washington and Franklin. There are
600,000 books and 3,000,000
manuscripts here. The art collection
includes Gainsborough's "Blue Boy" and
many other 18th and early 19th century
works. (Published by Museum
Reproductions, Alhambra, CA.)

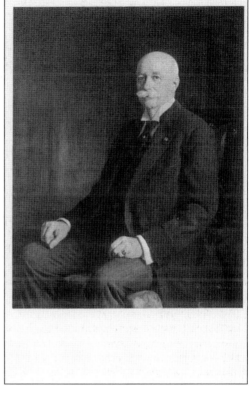

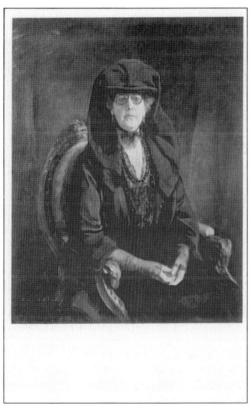

ARABELLA HUNTINGTON. After divorcing his
first wife, Henry Huntington married
Arabella, his uncle's widow, in 1913,
after he had retired from business affairs
and was working on his collections of
books and art. The west wing of the
library houses the Arabella D.
Huntington Memorial Collection,
including a group of Renaissance
paintings, as well as French paintings,
porcelains, and sculptures. Both
portraits of the Huntingtons are by Sir
Oswald Birley. (Published by Museum
Reproductions, Alhambra, CA.)

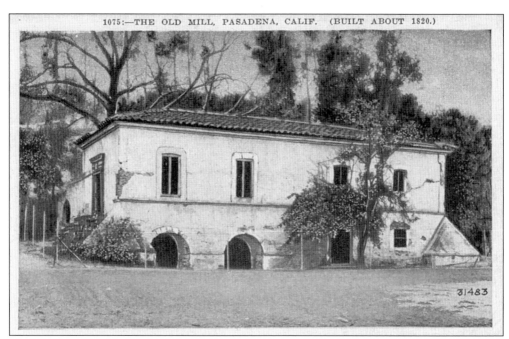

THE OLD MILL. Joseph Chapman, the first American to settle in California, built the Old Mill for father Jose Maria de Zalvidea in 1820. After changing ownership twice in the 19th century, the mill was acquired in 1903 by Henry E. Huntington. It is in the Oak Knoll area just west of San Marino. (Published by M. Kashower, Los Angeles.)

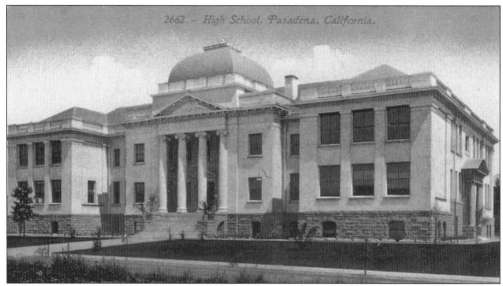

2662 – High School, Pasadena, California.

HIGH SCHOOL, PASADENA. Pasadena High School as pictured here was built in 1904. It was the first separate high school in the city, and was on the north side of Walnut Avenue between Euclid and Los Robles. A new high school was built on Colorado Street east of Hill Avenue and opened its doors in September 1913. It was considered to be "out in the country." The school on Walnut became John Muir Junior High School; it was razed about 1938. (Published by Edw. H. Mitchell, San Francisco.)

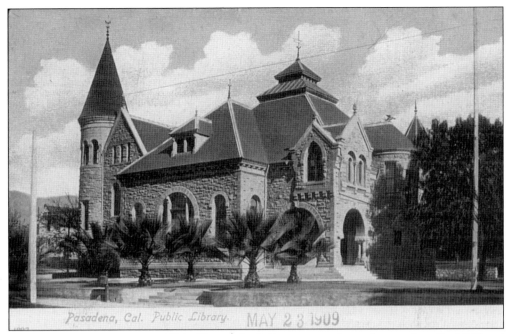

PASADENA PUBLIC LIBRARY. This library building opened on September 9, 1890, at Walnut Street and Raymond Avenue. Having served for a long lifetime, it was demolished in 1934 after suffering irreparable injuries in the earthquake of March 1933. Sadly, all that is left as a memorial are the portals of the front porch. (Published by Paul C. Koeber, New York.)

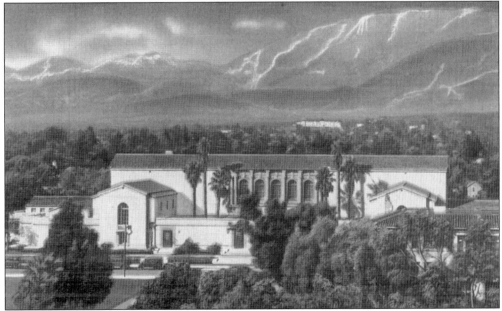

LIBRARY, SAN GABRIEL MOUNTAINS IN BACKGROUND. Designed by Hunt and Chambers in 1927, this Renaissance-style library building occupies the north end of the Civic Center area at 285 E. Walnut Street. (Published by Newman Post Card Co., Los Angeles.)

93

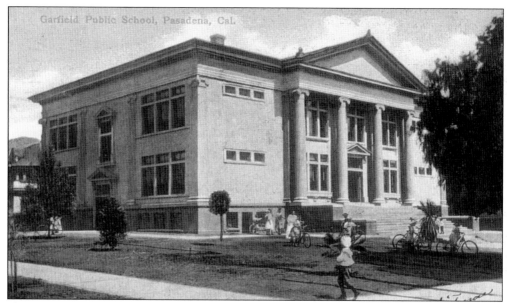

GARFIELD PUBLIC SCHOOL. Shown prior to 1909 when this postcard was mailed, Garfield School was located on the northeast corner of West California at Pasadena Avenue. The children playing on the sparse corner lawn wear clothing which helps date the scene. The classical architecture is typical of many schools built around 1900. (Published by Newman Post Card Co., Los Angeles.)

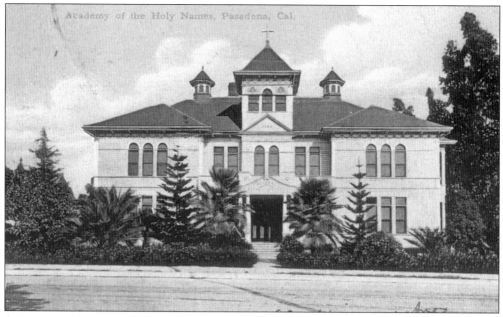

ACADEMY OF THE HOLY NAMES. This postcard mailed in 1909 has an interesting message: "Dear Helen, this school is on fair Oaks Avenue. I pass it when I go up town. It is a very old building—it is on one corner op. Walnut St...The Catholic church on the other corner." St. Andrews church was on the northeast corner. (Published by Newman Post Card Co., Los Angeles.)

94

Three
HOTELS

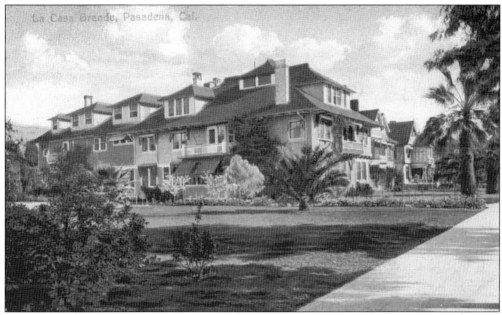

LA CASA GRANDE. The city of Pasadena had a slow start, beginning in 1873; however, it grew enormously after the real estate boom of 1886. Wealthy easterners discovered its tropical atmosphere and came in a steady stream to its resort hotels, which increased in number almost daily. La Casa Grande, in Pasadena, was built in the 1800s and was described as "a family hotel." It stood on the northwest corner of Colorado Street and Euclid Avenue; it was razed about 1920. (Published by Newman Post Card Co., Los Angeles.)

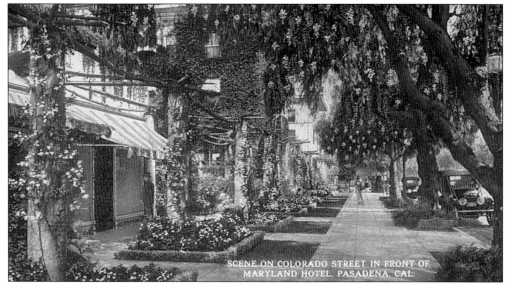

SCENE ON COLORADO STREET IN FRONT OF MARYLAND HOTEL. The Maryland Hotel was located on Colorado Boulevard between Euclid and Los Robles in a residential area just east of downtown. It became the center of Pasadena's social life, being the only hotel to remain open all year. In addition, it offered bungalows—individual houses with full hotel service —an amenity soon imitated by other hotels nearby. This view shows the hotel shops under the awning at left; the hotel is seen through the flower-entwined pergola farther down the street. (Published by Western Publishing & Novelty Co., Los Angeles.).

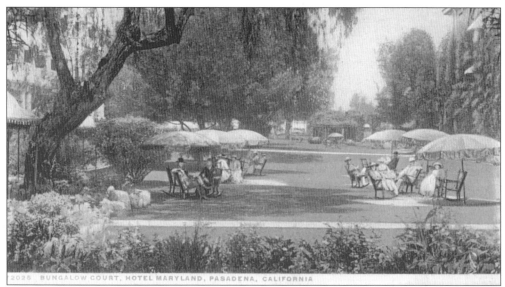

BUNGALOW COURT, HOTEL MARYLAND. In this large lawn and garden area on the grounds of the Maryland Hotel, guests enjoyed sitting outdoors under big umbrellas. Ladies wore long floating dresses and wide-brimmed afternoon hats. This was the perfect spot to greet one's friends at afternoon tea, or to have cool drinks at the cocktail hour. The Maryland was torn down in 1938 and replaced with the Broadway Department Store. (Published by Detroit Publishing Co., Detroit.)

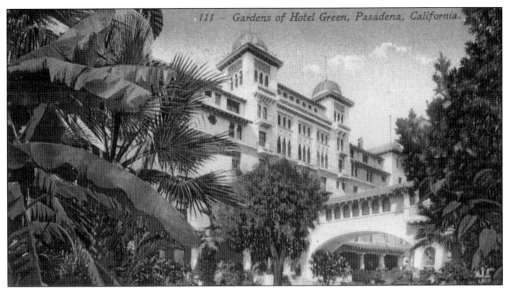

GARDENS OF THE HOTEL GREEN. Located in the center of town at 50 E. Green Street, Hotel Green appealed to visitors who preferred an urban atmosphere with shops and transportation immediately at hand. First called the Webster Hotel, it was built in 1890 by architect Frederick Roehrig, who used Moorish and Spanish colonial design elements. In the 1920s Roehrig tripled its size with elaborate bridged and arched additions. In later years the annex was torn down, and what remains today stands on the south side of Green Street between Fair Oaks and Raymond Avenues. (Published by Edward H. Mitchell, San Francisco.)

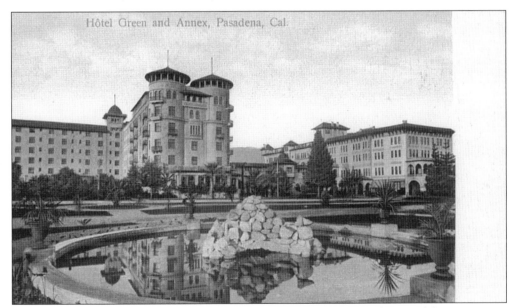

Hôtel Green and Annex, Pasadena, Cal.

HOTEL GREEN AND ANNEX. This 1895 photo of Hotel Green includes its elaborate annex approached over a walkway from the original building at left. Hotels of this era were so huge that a photographer had to stand a quarter of a mile away to get a fully extended view. (Published by M. Rieder, Los Angeles.)

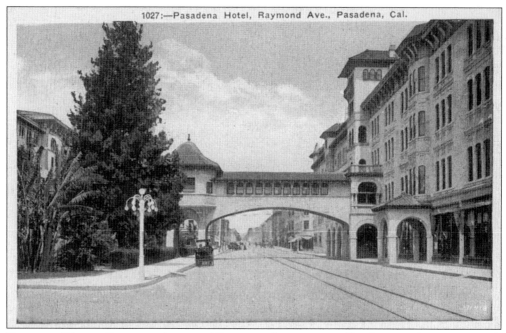

PASADENA HOTEL, RAYMOND AVENUE. The scene here is actually the Hotel Green, which occupied two buildings on opposite sides of the street, connected by this walkway. It looked this way in 1895. The postcard was misprinted with erroneous information. (Published by M. Kashower Co., Los Angeles.)

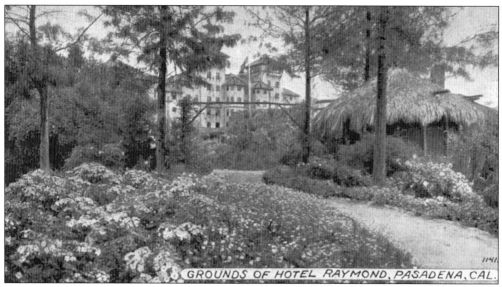

GROUNDS OF HOTEL RAYMOND, PASADENA, CAL.

GROUNDS OF HOTEL RAYMOND. The grounds of the Hotel Raymond were extensive, including a golf course and vistas of lawns and gardens. One could easily take many different exploratory walks and still remain on the grounds. This path arrived at Fair Oaks Avenue and the waiting station where one could take the trolley to downtown Pasadena. Theodore Payne, an expert on native plants and flowers, was the landscape artist. (Published by Acmegraph Co., Chicago.)

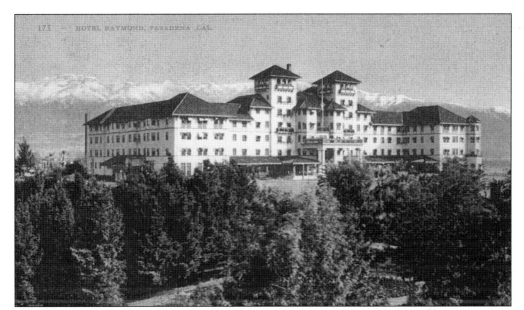

HOTEL RAYMOND. The picture shows the second Hotel Raymond, built on Raymond Hill in South Pasadena in December 1901. (The first hotel of the name had burned in 1895.) One of the services accorded guests was that of a carriage which met them at the railroad station; later an auto bus provided the ride. The hotel was torn down in 1934. (Published by Edward H. Mitchell, San Francisco.)

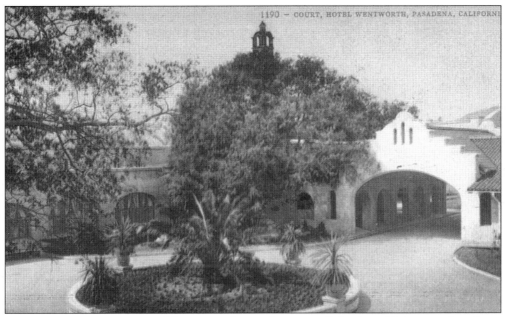

COURT, HOTEL WENTWORTH. This view shows the area of the Hotel Wentworth, where the Tap Room and the world famous Ship Room were located. These rooms looked out on the outdoor dancing area and the rooms for receptions and private parties. After a few years the Wentworth was renamed the Huntington Hotel. (Published by Edw. H. Mitchell, San Francisco.)

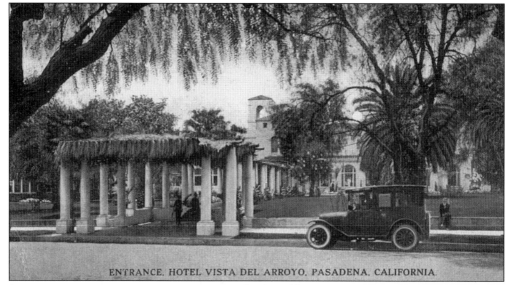

ENTRANCE. HOTEL VISTA DEL ARROYO. PASADENA. CALIFORNIA.

ENTRANCE, HOTEL VISTA DEL ARROYO. Perched on the east side of the Arroyo Seco, just south of the Colorado Street Bridge, the Vista ("View") del Arroyo is at the north end of Grand Avenue. In front we see the ubiquitous pergola; in the center distance we see windows which looked out of the main lobby. The hotel ceased operations when it was taken over by the government during World War II. (Published by Western Publishing & Novelty Co., Los Angeles.)

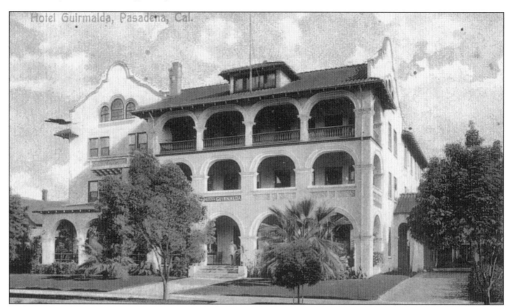

Hotel Guirnalda, Pasadena, Cal.

HOTEL GUIRNALDA. Located next door to the old First M.E. Church at 258 E. Colorado Boulevard, this small hotel has many attractive qualities. Architecturally speaking, it is styled in the Spanish mission or colonial manner, with huge arches and wide verandas on all three floors. Compared to the mammoth Green or Raymond Hotels, its three floors seem intimate in concept. It was built about 1902 and disappeared about 1920. (Published by Newman Post Card Co., Los Angeles.)

100

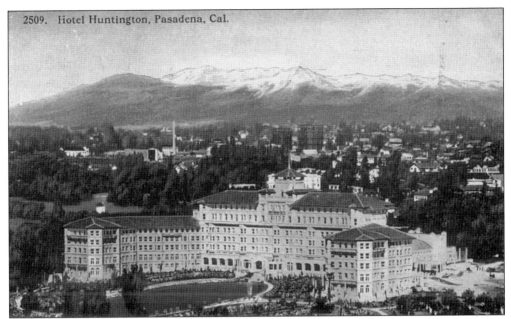

HOTEL HUNTINGTON. Now called the Ritz-Carlton Huntington, this mammoth luxury hotel dates from 1907; it is located at 1401 S. Oak Knoll Avenue, and for generations has been the hub of Pasadena society. It has 383 rooms and in addition 6 cottages in a turn-of-the-century country-club setting. Elaborate gardens designed by William Hetrick surround it; a wooden bridge between two wings overlooks the Japanese garden in the courtyard. (Published by Western Publishing & Novelty Co., Los Angeles.)

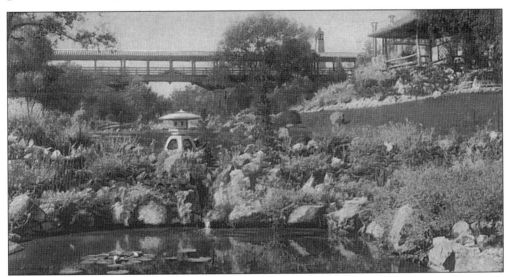

JAPANESE GARDEN, HUNTINGTON HOTEL. William Hetrick, the landscape designer, designed several kinds of gardens for Henry E. Huntington in 1904. On the hotel grounds he designed a Japanese garden containing elements of rocks, flowers, and flowing water to provide a place for quiet repose. There is also a famous picture bridge, seen at the top of this picture, which spans the garden. (Published by Detroit Publishing Co., Detroit.)

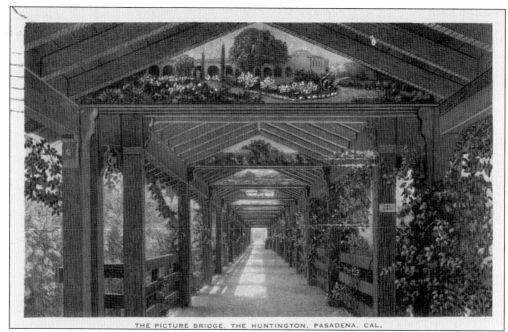

THE PICTURE BRIDGE, THE HUNTINGTON, PASADENA, CAL.

THE PICTURE BRIDGE. Spanning the Japanese garden at Hotel Huntington, the picture bridge presents a unique work of art. There are 41 paintings of California landmarks in the triangular pediments over the porticos of the bridge, forming an instant art gallery of scenes which are both unique and unexpected. (Published by E.C. Kropp, Milwaukee.)

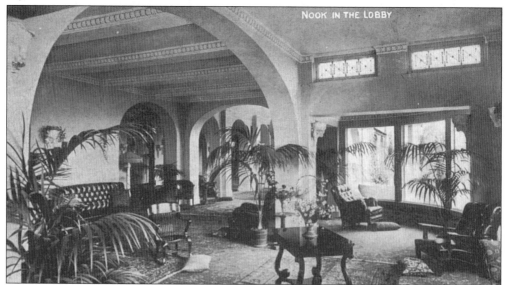

NOOK IN THE LOBBY

NOOK IN THE LOBBY. In a lavish hotel such as the Huntington, one might expect a parlor such as this in 1909. It is small and Victorian, with Oriental rugs, oversize tropical plants, and mahogany tables with flower-filled vases. The sofa at left is leather; the easy chairs are massive, and a foot pillow is present at each chair. Only one lamp is visible; this is not a room for heavy reading, only perhaps for conversation or reflection. (Published by George Rice & Sons, Los Angeles.)

Four
CHURCHES, MOUNTAINS, AND RAILWAYS

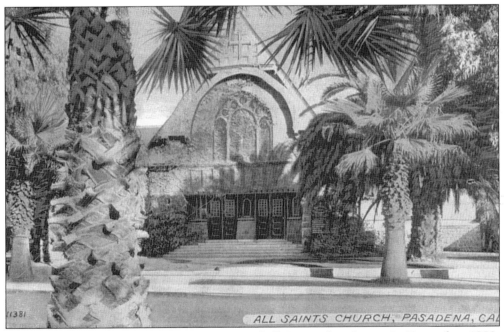

ALL SAINTS CHURCH. The first congregation of All Saints church met in November 1882, but did not inhabit this church on North Euclid Avenue until April 21, 1889. Later this church was outgrown, and a new cornerstone was laid on October 7, 1923. (Published by Acmegraph Co., Chicago.)

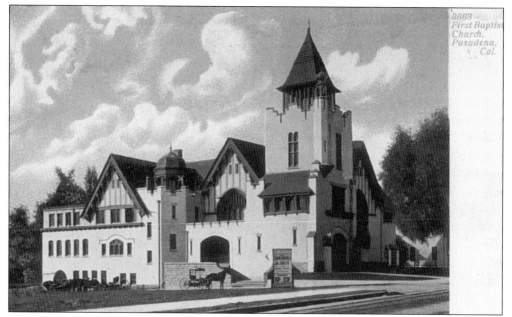

FIRST BAPTIST CHURCH. The first services held in the church pictured here took place in April 1904, on the northwest corner of Marengo and Union. In 1920 additional lots north of the church were purchased, and this church was razed in 1925. The new First Baptist Church was dedicated in 1926. (Published by Adolph Selige Pub. Co., St. Louis.)

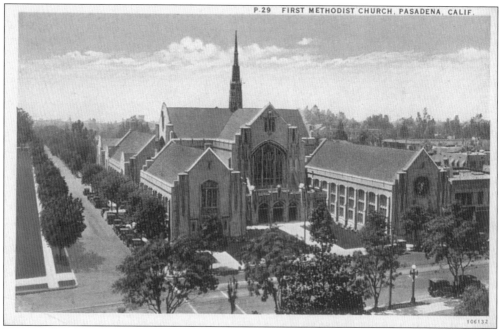

FIRST METHODIST CHURCH. Standing on the southwest corner of Colorado Boulevard and Oakland Avenue, the First United Methodist church held its first services in 1923. It is an elaborate Gothic-style building with outstanding stained-glass windows. (Published by Western Publishing & Novelty Co., Los Angeles.)

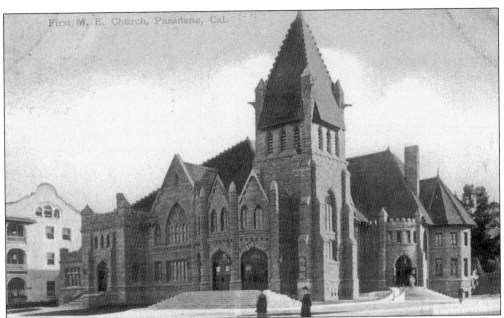

FIRST M.E. CHURCH. The First Methodist Church was built on the southeast corner of Colorado Boulevard and Marengo Avenue in 1901. It was constructed of stone with copper finishing on the steeple. When the new church was built in 1922 at Colorado and Oakland, the old church was dismantled and the stones given to Lake Avenue Methodist Church. (Published by Newman Post Card Co., Los Angeles.)

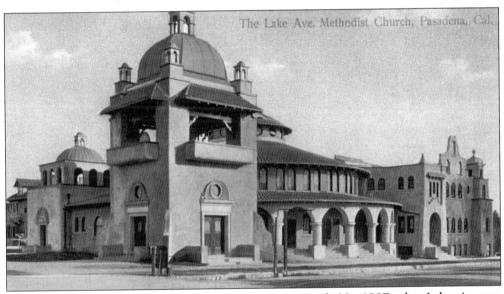

LAKE AVENUE METHODIST CHURCH. Dedicated on April 28, 1907, the Lake Avenue Methodist Church was located at East Colorado Boulevard and Lake Avenue. When the First Methodist built its present edifice in 1922, its old stone building with copper steeple was dismantled and given to the Lake Avenue church to build a new church on Holliston Avenue. This became the Holliston Avenue Methodist Church; the Lake Avenue Church was demolished. (Published by M. Rieder, Los Angeles.)

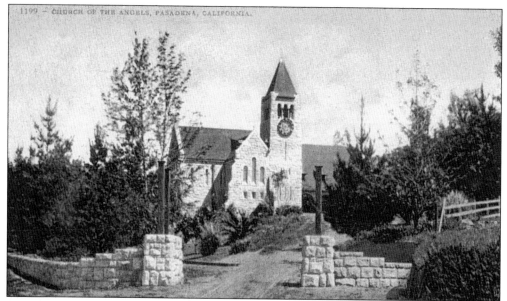

CHURCH OF THE ANGELS. The Episcopal Church of the Angels is on the west bank of the Arroyo Seco, and is one of the oldest Episcopal churches in the area. Its cornerstone was laid on Easter Eve in 1889. It is owned by the diocese and is known as the Bishop's Chapel, but it is home to a very active congregation. (Published by Edward H. Mitchell, San Francisco.)

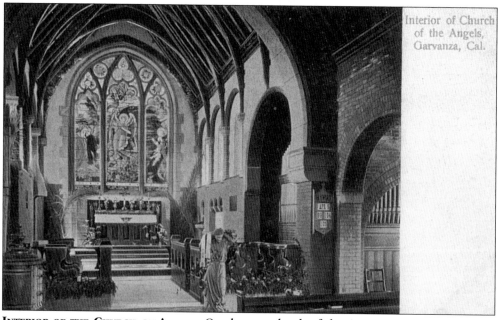

Interior of Church of the Angels, Garvanza, Cal.

INTERIOR OF THE CHURCH OF ANGELS. On the west bank of the Arroyo Seco, the beautiful sanctuary of the Episcopal Church of the Angels has welcomed worshippers since 1889. It contains the magnificent stained-glass window shipped from England at that time, as well as the original pipe organ. The interior arches and the sanctuary are also notable. The church is on Avenue 64 in Garvanza, a section of Highland Park adjacent to Pasadena.

FIRST CONGREGATIONAL CHURCH. Located on the northeast corner of Marengo Avenue and Green Street, the First Congregational Church opened its doors in the summer of 1904. Shortly after opening, an unfortunate event occurred: the steeple was destroyed in a storm. This, however, was to be the home of First Congregational until the present church was ready on Easter Sunday 1928. It is located at Walnut and Los Robles. (Published by Newman Post Card Co., Los Angeles.)

SAN GABRIEL MISSION BELLS. Missions are one of California's oldest and most durable legends. Their essence is the belief that missions were successful in Christianizing and civilizing savage Indians. Father Pedro Cambon and Angel Somera founded the San Gabriel Mission in 1771; the present mission consists of the remains and renovation of the original built in 1791. Constructed of stone, mortar, and brick, its design reflects that of the Cathedral of Cordova in Spain. It is located at 537 W. Mission Drive, San Gabriel. (Published by M. Rieder, Los Angeles.)

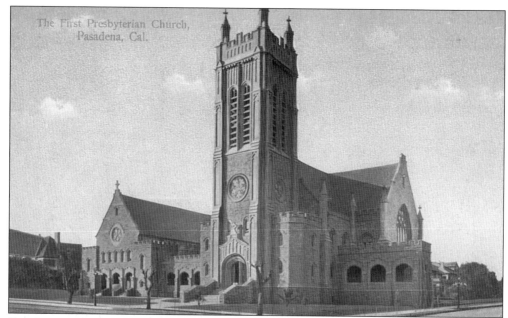

THE FIRST PRESBYTERIAN CHURCH. Located at Colorado Street and Madison Avenue, the Pasadena (First) Presbyterian Church was begun in 1906. Its congregation is the oldest in the city, dating from March 1875. The Victorian Gothic building, which served until 1971, had Tiffany lanterns and a bell tower housing 11 bells, the largest of which weighed 3 tons. (Published by M. Rieder, Los Angeles.)

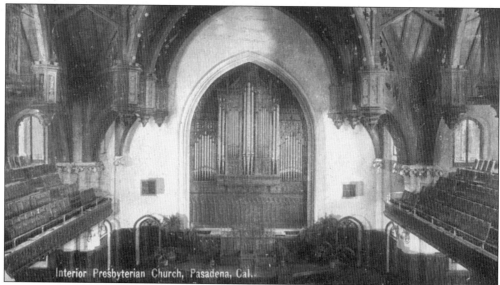

INTERIOR, PRESBYTERIAN CHURCH. The interior view of the sanctuary of the Pasadena (First) Presbyterian Church shows the elaborate woodcarvings and massive Gothic organ loft as they appeared in 1910. The church was so damaged by the Sylmar earthquake of February 1971, that it was torn down and rebuilt. The congregation still has its home at Colorado and Madison, and the bells from the original tower are in place. (Published by Newman Post Card Co., Los Angeles.)

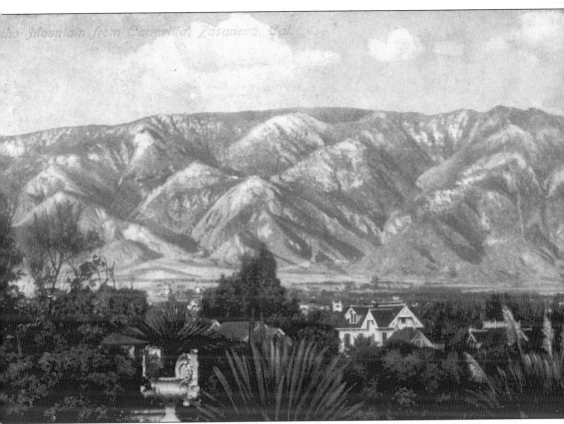

ECHO MOUNTAIN FROM CARMELITA. This early postcard view of Echo Mountain shows the San Gabriel Range with a light dusting of snow. The picture was taken from Carmelita near the Rose Bowl, and shows a large undeveloped area which is Altadena today. (Published by M. Rieder, Los Angeles.)

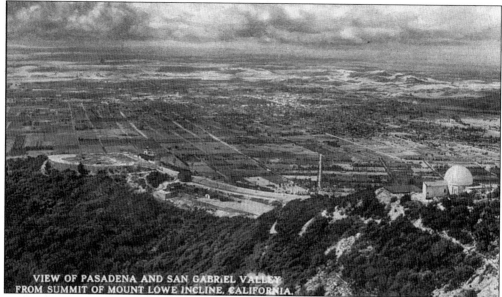

VIEW OF PASADENA AND SAN GABRIEL VALLEY. In the 1890s, delighted tourists traveled on the Mount Lowe Railroad to the top of Echo Mountain to view this scene. The observatory, seen here at lower right, was reached by a 3,000-foot-long incline. In the 1920s and 1930s, the San Gabriel Valley was a near paradise of dense orange, lemon, and walnut groves, with a lion, ostrich, and reptile farm in between. (Published by Western Publishing and Novelty Co., Los Angeles.)

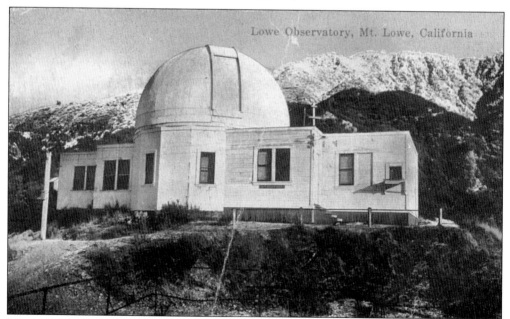

LOWE OBSERVATORY, MOUNT LOWE. This small observatory was built by Professor Thaddeus S.C. Lowe, a former Civil War balloonist, as part of the tourist excursion trip to Mount Lowe. The snow on the mountains provided an exciting contrast to the Southern California weather down below. (Published by M. Kashower Co., Los Angeles.)

110

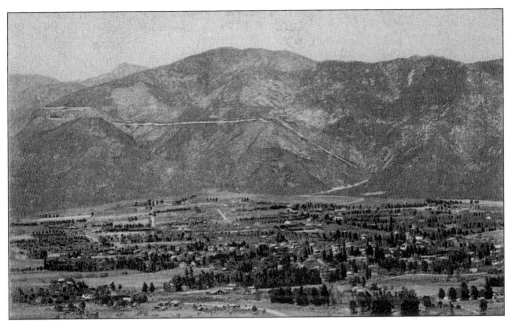

ECHO MOUNTAIN AND MOUNT LOWE FROM PASADENA. Looking at these mountains from below, they seemed an inaccessible wilderness, and, indeed they were until Prof. Lowe opened his railroad in 1893. Highways up the mountains didn't come until the 1930s. (Published by Detroit Publishing Co., Detroit.)

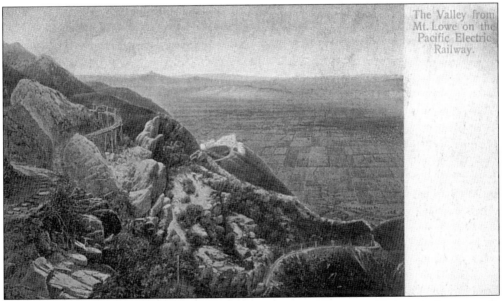

THE VALLEY FROM MOUNT LOWE ON THE PACIFIC ELECTRIC RAILWAY. Almost at the summit, we see here a trolley on the trestle rounding one of its last curves. At the foot of the mountain lies the San Gabriel Valley. A billboard advertisement of this trip read, "See 56 cities in one vast panorama from Mt. Lowe. $2.50 round trip. Five trains daily." The date was 1926. (Published by M. Rieder, Los Angeles.)

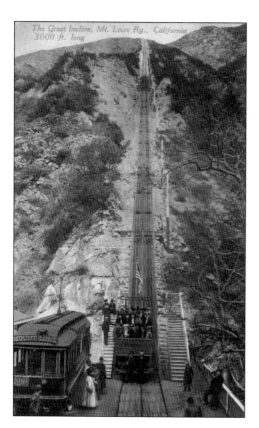

THE GREAT INCLINE, MOUNT LOWE. The Great Incline transported passengers by cable from a pavilion in Rubio Canyon (2,000-feet above sea level), up a 60 percent grade, to the summit of Echo Mountain (3,500-feet above sea level). From there they rode trolley cars around 127 curves and 18 trestles to the base of Mount Lowe and Ye Alpine Tavern. (Published by Newman Post Card Co., Los Angeles.)

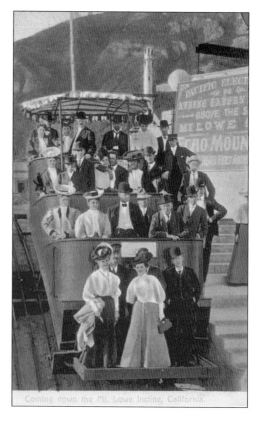

GOING DOWN THE MOUNT LOWE INCLINE. A good view of the Mount Lowe Incline car shows happy tourists about to descend the mountain. The time is about 1905. Ye Alpine Tavern prevailed at the summit until 1938, when it was destroyed by fire. (Published by Newman Post Card Co., Los Angeles.)

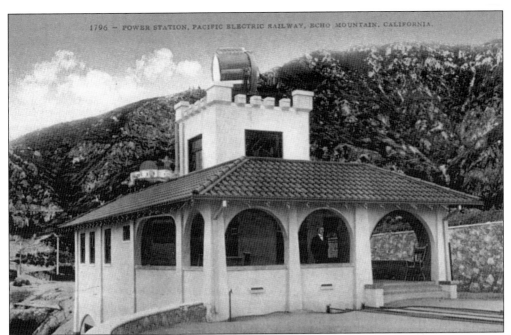

POWER STATION, PACIFIC ELECTRIC RAILWAY, ECHO MOUNTAIN. The Power Station on Echo Mountain was 3,200-feet above sea level. The cable cars that traversed the Great Incline were controlled from this building at the top of the Incline. The farther distant Lowe Observatory on Mount Lowe can be seen to the left of the tower. The searchlight on top of the tower dwarfs the man standing next to it. (Published by Edw. H. Mitchell, San Francisco.)

ON THE ROAD TO ALPINE TAVERN. The considerable accomplishments of Prof. T.S. C. Lowe can be seen here—a part of the winding railroad which he built up the mountain to Alpine Tavern. A portion of one of the many trestles is at the lower right. The San Gabriel Mountains were virtually inaccessible to most travelers until Lowe provided his railroad. (Published by M. Rieder, Los Angeles.)

113

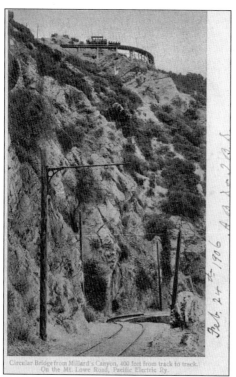

CIRCULAR BRIDGE FROM MILLARD'S CANYON. This postcard, mailed in 1906, views the circular bridge at the summit of Mount Lowe, which provided an unparalleled panorama of the San Gabriel Valley below. The trestles, however, were made of wood, and when the fire broke out in 1938, the forest conflagration destroyed the Alpine Tavern as well as the tracks. This was the end of a wonderful trip on the "Road of a Thousand Wonders." (Published by M. Rieder, Los Angeles.)

Circular Bridge from Millard's Canyon, 400 feet from track to track. On the Mt. Lowe Road, Pacific Electric Ry.

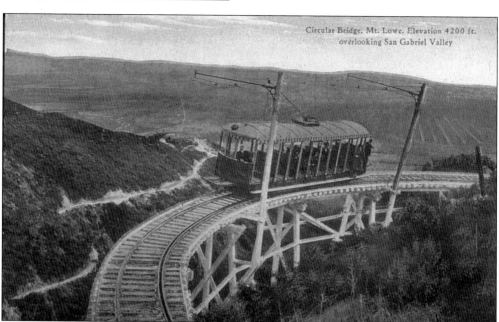

CIRCULAR BRIDGE, ELEVATION 4,200 FEET. A different perspective of car and high trestle indicates the "wonders" to see in the San Gabriel Valley below. The trolleys were open-sided, which allowed passengers to be scared or enthralled, whichever they wished. In this picture, two men show their courage—or perhaps their foolhardiness—by hanging off the rear of the car. (Published by Western Publishing & Novelty Co., Los Angeles.)

CLIMBING BY TROLLEY, MOUNT LOWE. Three trolleys at different levels are shown here climbing Mount Lowe. Part of the fun of riding them must have been feeling the danger inherent in the open sides of the vehicles. It would have been easy to fall out. (Published by E.C. Kropp Co., Milwaukee.)

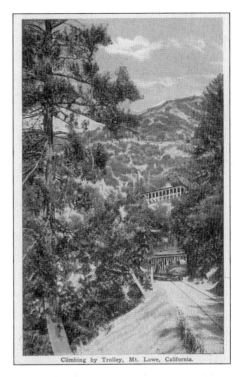

Climbing by Trolley, Mt. Lowe, California.

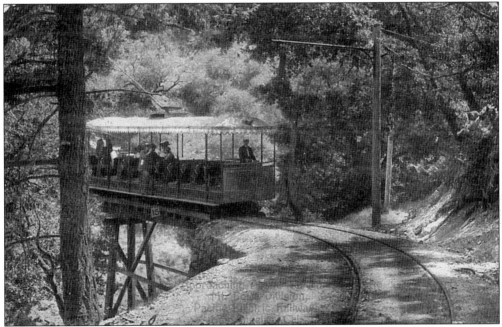

APPROACHING YE ALPINE TAVERN. An open trolley is here arriving at Ye Alpine Tavern. The tavern and its cottages were situated at the summit of Mount Lowe and provided lodging as well as dining facilities. The trip to Mount Lowe was advertised as a "two-hour scenic mountain trolley trip—unparalleled in its grandeur." The postcard was sent in 1907. (Published by Newman Post Card Co., Los Angeles.)

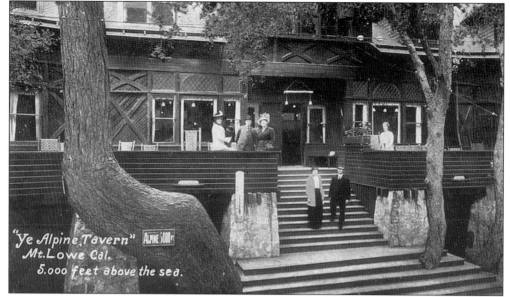

YE ALPINE TAVERN. The final destination for those who took the trip to Mount Lowe was Ye Alpine Tavern. Widely advertised, it was a primary tourist attraction "On the Road of a Thousand Wonders." The tavern provided lodging upstairs for those who wished to spend the night and a large number of cottages as well. It also had a large front porch with chairs for relaxing. (A Mount Lowe Postcard.)

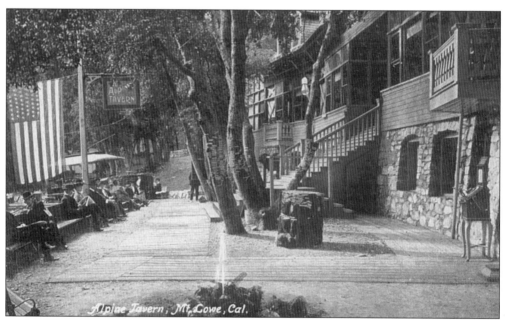

YE ALPINE TAVERN, MOUNT LOWE. Destination is reached here for a number of tourists—the front, or reception area of Ye Alpine Tavern. Relaxed travelers read the paper or simply rest on the benches at left; there is a water fountain in the foreground, and a huge electric light globe hangs from the tree trunk at right center. (Published by M. Rieder, Los Angeles.)

116

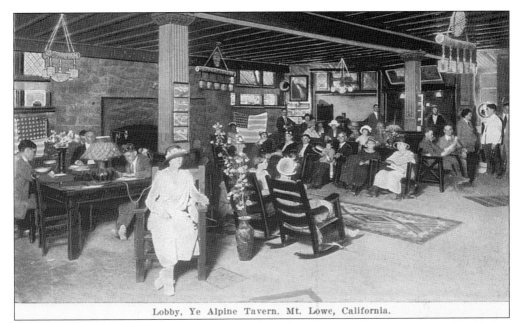

Lobby, Ye Alpine Tavern, Mt. Lowe, California.

LOBBY, YE ALPINE TAVERN. A convenient place for the traveler to rest was Ye Alpine Tavern lobby. It provided a dining room as well as writing desks and comfortable rocking chairs. After the two-hour trip it was the place to wait and relax before starting the trip back. The American flag seems to be a preferred item of decor here. (Published by E.C. Kropp, Milwaukee.)

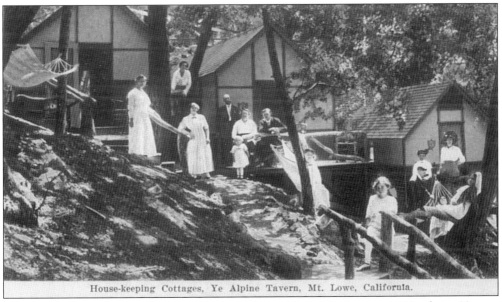

House-keeping Cottages, Ye Alpine Tavern, Mt. Lowe, California.

HOUSEKEEPING COTTAGES, YE ALPINE TAVERN. Those who wished to stay at Ye Alpine Tavern overnight, or for a more extended period, found housekeeping cottages available at the back of the tavern. Many people took advantage of this opportunity, especially those with families who wished to vacation together at this mountain resort. The hammocks proved to be one of the most popular features. (Published by E.C. Kropp, Milwaukee.)

117

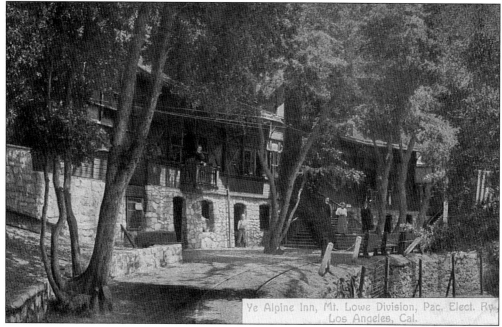

Ye Alpine Inn, Mt. Lowe Division, Pac. Elect. Ry. Los Angeles, Cal.

YE ALPINE INN. Another view of Alpine Tavern (here called an Inn) shows a building of rustic ambiance, which imitated a Swiss chalet. The trees are especially important because of their mature size and their position close to the building. The feeling of being outdoors is barely interrupted by the structure—a fine adaptation architecturally of building to surroundings. (Published by Newman Post Card Co., Los Angeles.)

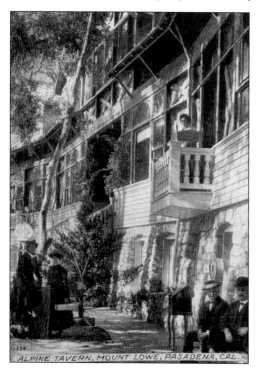

ALPINE TAVERN, MOUNT LOWE, PASADENA, CAL.

YE ALPINE TAVERN. A close-up of the front of Ye Alpine Tavern reveals a few more details. Everyone seems to be posing for this picture, even the lady on the balcony, who has turned around in her chair to look at the camera. One wonders what season it is—the foliage is green, but the ladies on the ground are wearing heavy-looking skirts and jackets. Is the box, carried by the lady in black, a substitute for an overnight bag? (Published by Acmegraph Co. Chicago.)

118

Five
SCENES AND SIGHTS

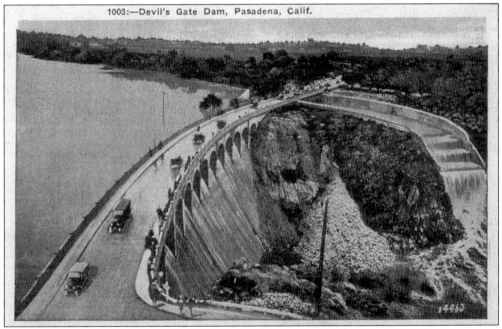

1003:—Devil's Gate Dam, Pasadena, Calif.

DEVIL'S GATE DAM. At the head of the Arroyo Seco, Devil's Gate Dam provides a vital water supply as well as being indispensable to flood control. Without it the Rose Bowl and Brookside Park could not exist. Until the new freeway was completed, the road pictured above was the main connector from Altadena to Flintridge-La Canada and points west. (Published by M. Kashower, Los Angeles.)

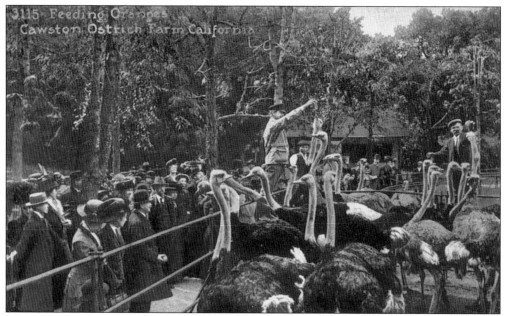

FEEDING ORANGES, CAWSTON OSTRICH FARM. Located in South Pasadena at Sycamore and Pasadena Avenues, Cawston Ostrich Farms opened in November 1896. Not only a popular tourist attraction for many years, the birds also supplied plumes, which were a must on every well-dressed lady's hat. Advertisements for the farm featured collars, muffs, and fans; the claim was that "We own over 200 ostriches and obtain over 80,000 feathers yearly." (Published by Edw. Mitchell, San Francisco.)

FEEDING ORANGES, CAWSTON OSTRICH FARM. This card is dated 1913. As the years passed, fashions changed and by 1916 ostrich feathers were no longer in demand. The Cawston Ostrich Farm continued as a tourist attraction, but closed in 1935. (Published by Newman Post Card Co., Los Angeles.)

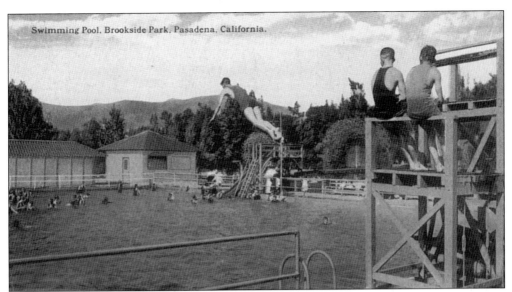

Swimming Pool, Brookside Park, Pasadena, California.

SWIMMING POOL, BROOKSIDE PARK. In 1914, Mrs. E.W. Brooks donated funds to build a "municipal plunge." The pool became a popular attraction through the years and is still in use today. In 1932 it was enlarged to accommodate the Olympic Games so that water polo and diving events might be held there. Brookside Park is located just north of the Colorado Street Bridge, to the south of the Rose Bowl. (Published by Western Publishing & Novelty Co., Los Angeles.)

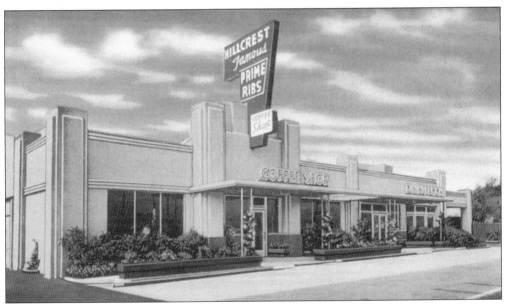

HILLCREST RESTAURANT. A postcard from the 1930s pictures one of the many small restaurants that sprang up during this decade. With clean Art Deco architectural lines, it offered motorists both a snack and coffee in the coffee shop, or a full dinner in the restaurant. Located at 3570 E. Foothill Boulevard, the Hillcrest opened at 11 a.m., was closed on Mondays, and offered "luncheon, dinner, fountain, and snacks." It occupied the "same location since 1922." (Published by Mellinger Studios, Altadena.)

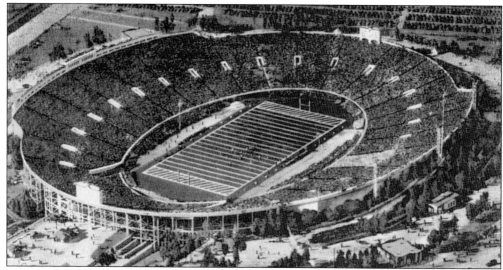

THE ROSE BOWL. The famous stadium pictured here holds more than 100,000 people who watch the annual New Year's Day football game between championship teams from the West and Midwest. It was built in 1922, and since has been the focus of the Tournament of Roses festival. The now elaborate festivities began in 1890 on a small scale with events other than football, but now has changed and grown to mammoth size. (Published by Western Publishing & Novelty Co., Los Angeles.)

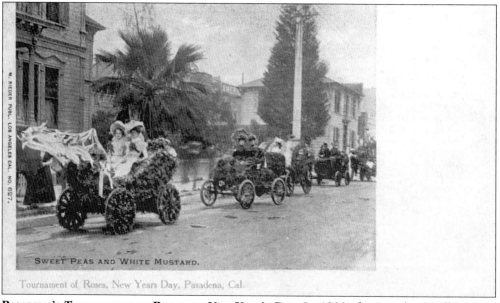

PASADENA'S TOURNAMENT OF ROSES ON NEW YEAR'S DAY. In 1890, the Pasadena Valley Hunt Club held its first Tournament of Roses parade to celebrate and advertise the region's balmy winters. Early on there were horse-drawn carriages draped with rose garlands. As years went by, more and more complex flower combinations were used, and automobiles replaced carriages. Here, the 1904 Tournament of Roses Parade moves down Colorado Street with, as yet, not much of an audience. Nothing but real flowers were ever used; in this picture they were "sweet peas and white mustard." (Published by Rieder, Los Angeles.)

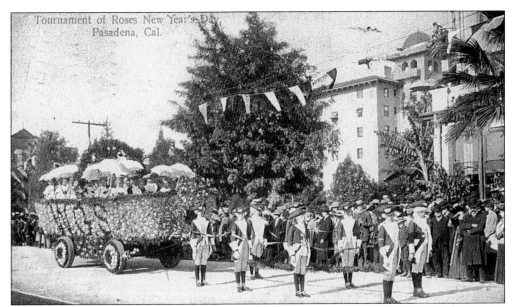

PASADENA'S TOURNAMENT OF ROSES ON NEW YEAR'S DAY. This entry in the 1907 Tournament of Roses Parade was typical of the period. Young men in colonial dress are seen pulling a large floral basket, filled with pretty young ladies with parasols and a few young gentlemen. The Green Hotel, which is no longer along the parade route, can be seen in the background. During this time, the parade ended at Tournament Park on California Street. (Published by M. Rieder, Los Angeles.)

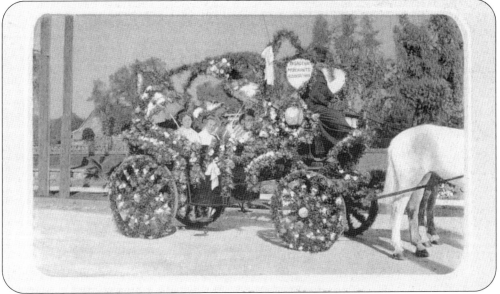

PASADENA'S TOURNAMENT OF ROSES ON NEW YEAR'S DAY. The Rose Parade in 1909 contained this flower-bedecked barouche drawn by two horses. According to the sign just above the headlamp, the float was entered by the Pasadena Merchants Association, and the flowers are described as "a study in pink ivy geraniums, white stevias, and graceful strands of smilax." (Published by Newman Post Card Co., Los Angeles.)

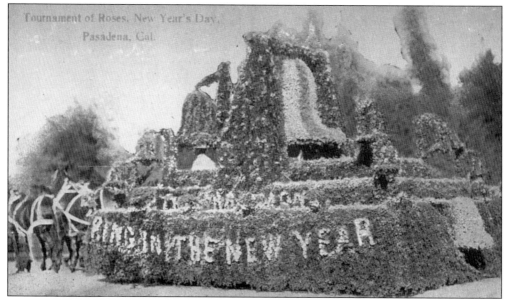

PASADENA'S TOURNAMENT OF ROSES ON NEW YEAR'S DAY. This float in the 1912 parade was horse-drawn, although motorized vehicles had been in parades much earlier. The message on the back of this card reads: "This year we had 4 miles. One hour and 15 minutes to pass a point. Rogers from a flying machine scattered roses over the crowd." C.P. Rodgers crossed the continent in an airplane and led the 1912 parade in his machine. (Published by M. Rieder, Los Angeles.)

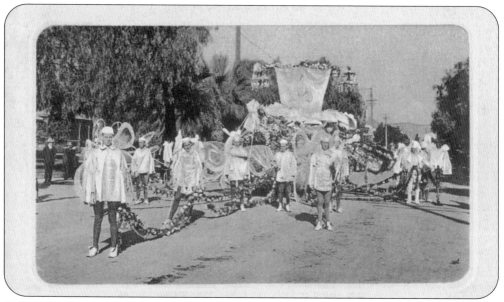

PASADENA'S TOURNAMENT OF ROSES ON NEW YEAR'S DAY. The Pasadena High School float in the 1909 parade is shown here. The float was described as "a barge with banks of oars on either side and filled with pretty girls. Decorated in pink roses, ivy geraniums, and carnations. Drawn by eight butterflies attached by ropes of roses and silver, and flanked by outriders." (Published by Newman Post Card Co., Los Angeles.)

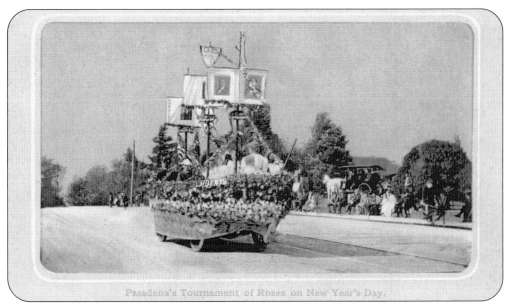

PASADENA'S TOURNAMENT OF ROSES ON NEW YEAR'S DAY. This motorized float in the Tournament of Roses parade of 1909 is the entry from Ohio. Representing a boat in full sail, the sails themselves show pictures of United States Presidents native to Ohio. An interesting part of this scene is the surrey and its white horse at right. It was estimated that 100,000 spectators watched the parade that year. (Published by Newman Post Card Co., Los Angeles.)

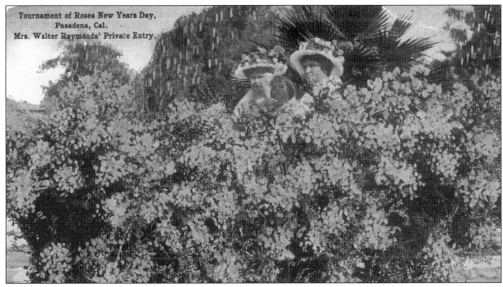

PASADENA'S TOURNAMENT OF ROSES—MRS. WALTER RAYMOND'S PRIVATE ENTRY. Mrs. Walter Raymond of the Raymond Hotel was a regular entrant in early Tournament of Roses parades. It is hard to identify the flowers, but the profusion of them on her large automobile is impressive. The Huntington Hotel and the Salvation Army floats also were seen in every parade for many years. (Published by Western Publishing & Novelty Co., Los Angeles.)

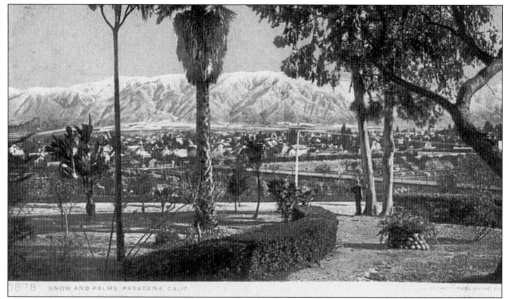

SNOW AND PALMS. This early picture of the residential section of Pasadena, with the mountains in the background, was used as an advertisement to entice people to come to Pasadena. The back of the card informs us: "The climate is ideal, the air being dry and bracing. The San Gabriel Valley is the choicest section of Los Angeles County… Here are found many fine resort hotels, which in winter are filled with thousands of guests from the East." (Published by the Detroit Publishing Co., Detroit.)

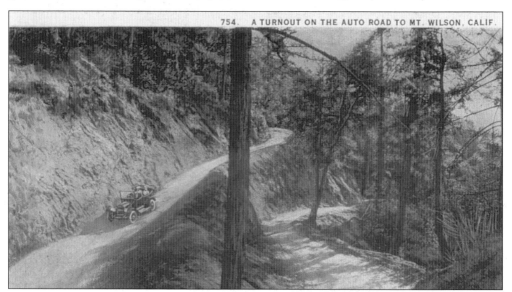

A TURNOUT ON THE AUTO ROAD TO MOUNT WILSON. This road went north from La Canada and curved around to the east until it reached Mount Wilson directly above Sierra Madre. This card was mailed April 2, 1928; the message reads: "We slithered around this turn this a.m. Fay, her sister Mrs. Hanson, Mrs. A. and I. We are 6,000 feet high with a cloud over us and we cannot see much. Love to all. Your wayward daughter." (Published by Western Publishing & Novelty Co., Los Angeles.)

126

RUBIO CANYON, FOOT OF INCLINE. A glimpse into the beauty of Rubio Canyon is shown here on a postcard mailed in 1933. A visitor could walk up these steps beside the tumbling mountain stream to a landing, at which point he would board the incline cable car and ride up to the summit of Echo Mountain. Others simply rode a trolley to the landing and forfeited the picturesque view. (Published by Western Publishing & Novelty Co., Los Angeles.)

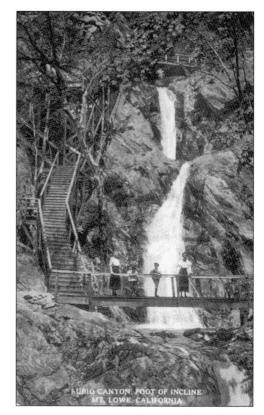

FOREST FIRE IN THE MOUNTAINS, MOUNT LOWE. Forest fires in the California Mountains are almost the norm every few years. After a winter of extensive rain the underbrush becomes very thick, and when a dry spell occurs it becomes very vulnerable to fire. It was such a fire as pictured here that finally destroyed Ye Alpine Tavern and the tracks to it in 1938. (Published by Edward H. Mitchell, San Francisco.)

BIBLIOGRAPHY

Apostol, Jane. *South Pasadena 1888–1988: A Centennial History*. South Pasadena: Typecraft, 1987.

Brown, Lee. *Where Was It? (In Early Los Angeles)*. Privately printed. No date.

Caughey, John and La Ree. *Los Angeles: Biography of a City*. Berkeley: University of California Press, 1976.

Crump, Spencer. *Ride the Big Red Cars: How Trolleys Helped Build Southern California*. Los Angeles: Crest Publications, 1962.

Ellington, Darcy, editor. *America's New Year Celebration: The Rose Parade and the Rose Bowl Game*. Santa Barbara: Albion Publishing Group, 1999.

Eyewitness Travel Guides. *California*. London: DK Publishing, 1997.

Los Angeles Times. Home Section. October 22, 1961.

Nicholson, Francis Baum. *Celebrating the Past—Imagining the Future: Pasadena Presbyterian Church, 125th Anniversary*. No publisher. No date.

Reavill, Gil. *Hollywood and the Best of Los Angeles*. Oakland: 1994.

Time Out: Los Angeles Guide. London: Penguin Books, 1997.

Walker, Randi Jones. *Kept by Grace: A Centennial History of First Congregational Church of Pasadena*. Pasadena: Hope Publishing House, 1986.

Wurman, Richard Saul. *LA Access*. Los Angeles: Access Press, 1993.